IMAGES
of America

DUNDALK

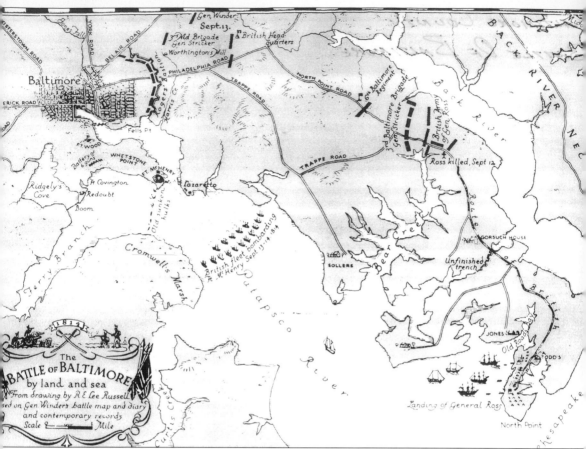

When British forces landed at North Point the morning of September 12, 1814, they couldn't have imagined that before the day would end, their commander, Maj. Gen. Robert Ross, would be dead and their efforts to capture Baltimore overland would be repulsed by Maryland militiamen from the 5th Regiment. With the simultaneous defense of Fort McHenry, Britain's two-year quest to reclaim its former colonies came to an abrupt end. (Courtesy Dundalk–Patapsco Neck Historical Society Museum.)

IMAGES
of America

DUNDALK

Gary Helton

ARCADIA

Published by Arcadia Publishing
Charleston SC, Chicago IL, Portsmouth NH, San Francisco CA

Printed in Great Britain

Library of Congress Catalog Card Number: 2005932041

For all general information contact Arcadia Publishing at:
Telephone 843-853-2070
Fax 843-853-0044
E-mail sales@arcadiapublishing.com
For customer service and orders:
Toll-Free 1-888-313-2665

Visit us on the Internet at www.arcadiapublishing.com

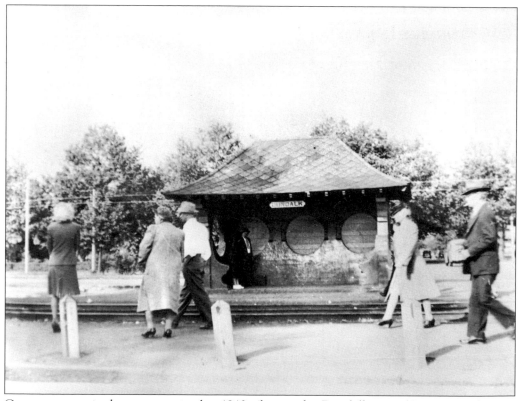

Commuters await the streetcar in this 1940s shot at the Dundalk stop. (Courtesy Baltimore County Public Library.)

CONTENTS

Acknowledgments 6

Introduction 7

1. A Spirit Unbridled 9

2. Business and Industry 19

3. Neighbors and Neighborhoods 49

4. The Military Presence 73

5. Schools 85

6. Churches 95

7. Recreation 105

8. Moments to Remember 119

ACKNOWLEDGMENTS

The author wishes to acknowledge the following individuals for their inspiration and support during this project: Carla Crisp of Dundalk Renaissance for planting the seed that became this book, Marcee Zakwieia for her contributions of photographs and information, and Bill Bates, who connected me with Arcadia Publishing. I'm also grateful to James Miller, Virginia Miller, and Marcella Pac for their assistance identifying the subjects in many of the shots from Sparrows Point. I appreciate the photograph contributions of Dr. Theodore Patterson, Virginia Gallick, Robert Parsons and Jason Domasky of the Baltimore County Public Library, and Colin Ebert on behalf of his father, William Ebert. I very much thank my son, Jason Helton, for his scanning assistance and computer expertise, and my 14-year-old dog, Mr. Shultz, for just lying around nearby as I typed away and stressed over deadlines (although I could have done without the gas). I especially thank Jean Walker and the entire staff at the Dundalk–Patapsco Neck Historical Society Museum—particularly Gladys Echols—without whom this book could not have been made. And finally I thank my bride of 30 years, Mary Ellen Helton, who, when she met me in the office of Patapsco High School in 1971, couldn't have fathomed what she was in for. You can have the PC back now, Hon, but the remote's still mine.

—Gary Helton
September 9, 2005

INTRODUCTION

Capt. John Smith of Virginia's Jamestown settlement landed on Patapsco Neck in 1608 while exploring Chesapeake Bay. Thomas Sparrow received the area's first land grant in 1652. But the story of Dundalk as we know it today begins in the stifling summer heat of 1894. That's when Baltimore businessman William McShane purchased 23 acres of land in the sparsely populated pocket of eastern Baltimore County, then known as St. Helena. William, one of two sons of renowned bell maker Harry McShane of Ireland, would use the newly acquired property to manufacture plumbing fixtures, leaving six acres on the Patapsco River for his own summer home. Situated alongside the Baltimore & Sparrows Point Railroad, the new plant opened in May 1895. To provide service, railroad officials reportedly required a name for the freight station McShane built adjacent the plant. Legend has it that the businessman picked up a piece of scrap wood, scrawled the name of his father's hometown on it, and affixed the crude marker to the station. That name was "Dundalk."

While history gives William McShane credit for renaming the area, he was hardly the first to set up shop here. Pennsylvania Steel had already fired up its blast furnaces at Sparrows Point and, by 1887, was busy constructing housing for its workers. Brick makers Burns and Russell, founded in 1790, began manufacturing on a 125-acre parcel near what is now Logan Village in 1885. For recreation, there was "Lowrey's Place on Colgate Creek." This popular beer garden opened in 1868 along what is now Broening Highway and would later evolve into Riverview Park. And throughout the region, farms tended by the Lynch, Merritt, Diehl, Gray, Todd, and Stansbury families, among others, dotted the land. These names are still associated with Dundalk and Patapsco Neck.

Save for the British invasion of September 12, 1814, the most significant development in the region probably occurred in 1916. That was when Bethlehem Steel purchased what was by now the Maryland Steel Company plant at Sparrows Point, along with 1,000 acres. A year later, their real estate division, the Dundalk Company, began to carve out "a working man's Roland Park" following the attractive design of that upscale Baltimore neighborhood. The new community, just a few hundred yards from McShane's original Dundalk freight station, would provide housing for Bethlehem's employees, leaving space for future schools, parks, businesses, playgrounds, churches, and more. It was 1917, and the heart of Dundalk was born.

By 1920, that young heart was beating strong and steady. More than 4,000 souls occupied the new community's hastily built stucco homes situated on streets lined with sycamore trees. Police and fire stations were established on Shipping Place. The post office moved from a St. Helena store to the new Dunleer Building, and carrier service was initiated. Busy Camp Holabird, established at the end of World War I, was a beehive of activity at Dundalk and Holabird Avenues. Logan Field opened, beginning air service to and from Baltimore. William McShane's Maryland Swimming Club boasted first-rate clay tennis courts, not to mention a popular bathing beach. And streetcars brought thousands of fun seekers from Baltimore to Bay Shore and Riverview Parks for a day of swimming, picnicking, concerts, and rides.

Hollywood came to the area early in the 20th century with the Casino and Lyceum theatres in Sparrows Point. In 1926, the landmark Strand Theatre opened. The Colgate, Carlton, and Abbey Lane theatres on Dundalk Avenue and the Anthony on Main Street in Turner Station would later join it.

By the 1930s, Riverview Park had closed to make way for Western Electric, and construction had begun on Harbor Field, a new municipal airport rising from wetlands across Dundalk Avenue from Logan Field. A victim of the progress was the Maryland Swimming Club, whose beach disappeared under the weight of tons of fill dirt transported from "Kimmel's Mountain," site of the present-day Community College of Baltimore County (CCBC), Dundalk Campus. Besides Bethlehem, major employers of the day included General Motors, Standard Oil, and Crown Cork and Seal. The decade also witnessed the founding of the Heritage Association, beginning Dundalk's annual tradition of Fourth of July parades.

In the 1940s, the population of Greater Dundalk grew to over 10,000. A fine new post office was erected along with temporary housing for defense workers near the Turner Station community. Businessman Ted Graff established the Dundalk Bus Lines in 1947, affectionately referred to as "The Blue Bus." That same year, Bay Shore Park closed after the property was acquired by Bethlehem Steel.

A decade later, Bethlehem's Sparrows Point facility became the largest steel plant in the world, Eastpoint Shopping Center opened, and Harbor Field was replaced by Friendship International Airport, now BWI. By 1960, more than 80,000 people called Dundalk home.

The baby boom necessitated a hectic period of public school construction in the 1950s and 1960s. From these institutions came many of Dundalk's noteworthy alumni, including NFL great Calvin Hill, baseball's Ron Swoboda, former NAACP president and U.S. congressman Kweisi Mfume, and *Sesame Street* puppeteer Kevin Clash. By the late 1960s, Dundalk's public schools had fully integrated.

The final quarter of the 20th century brought about even more dramatic changes and not all of them welcome. The last company-owned homes in Sparrows Point were demolished to make way for plant expansion. Police stations in Edgemere and Dundalk merged into a single North Point precinct. The classic Brentwood Inn, with its world-famous wine cellar, closed its doors, as did the Strand and Carlton theatres, Fradkin Brothers Furniture, and the North Point Drive-In. Dundalk Community College was established, and the Francis Scott Key Bridge opened, forming the final link in Baltimore's Beltway. A tragic fire in 1984 destroyed a local furniture store and took the lives of three firefighters. Fire also temporarily closed Berkshire Elementary School. "The Blue Bus" disappeared, as did American Standard, Western Electric, Fort Holabird, and the Fort Howard VA Hospital. In 1981, the Central Foundry building— last remnant of William McShane's plumbing fixture plant established in 1895—fell to the wrecker's ball. Eventually Bethlehem Steel, which once employed over 30,000, was sold and then vanished altogether in bankruptcy.

Today, despite the loss of most of Dundalk's manufacturing base, a renaissance is underway. New public and private projects are planned, designed to beautify streetscapes, attract new business, and exploit the area's waterfront location. They are a testament to the strength and spirit of the scores of hard-working, friendly, patriotic, and unpretentious souls who have made, and continue to make, this little pocket of eastern Baltimore County their home.

One

A Spirit Unbridled

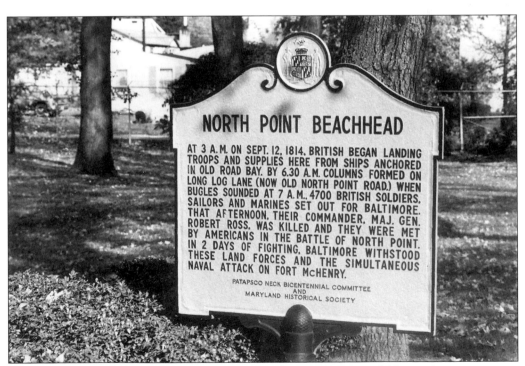

NORTH POINT BEACHHEAD

AT 3 A.M. ON SEPT. 12, 1814, BRITISH BEGAN LANDING TROOPS AND SUPPLIES HERE FROM SHIPS ANCHORED IN OLD ROAD BAY. BY 6.30 A.M. COLUMNS FORMED ON LONG LOG LANE (NOW OLD NORTH POINT ROAD.) WHEN BUGLES SOUNDED AT 7 A.M., 4700 BRITISH SOLDIERS, SAILORS AND MARINES SET OUT FOR BALTIMORE. THAT AFTERNOON, THEIR COMMANDER, MAJ. GEN. ROBERT ROSS, WAS KILLED AND THEY WERE MET BY AMERICANS IN THE BATTLE OF NORTH POINT. IN 2 DAYS OF FIGHTING, BALTIMORE WITHSTOOD THESE LAND FORCES AND THE SIMULTANEOUS NAVAL ATTACK ON FORT McHENRY.

PATAPSCO NECK BICENTENNIAL COMMITTEE
AND
MARYLAND HISTORICAL SOCIETY

Although occupied by white colonists for more than a century and Native Americans even longer (perhaps as much as 9,000 years), the character of the region and its people would not be defined until September 12, 1814. This historical marker, located at Fort Howard, tells the story of the British defeat that day. It also tells of a fierce, independent spirit that remains ingrained in area residents to this day. (Courtesy Dundalk–Patapsco Neck Historical Society Museum.)

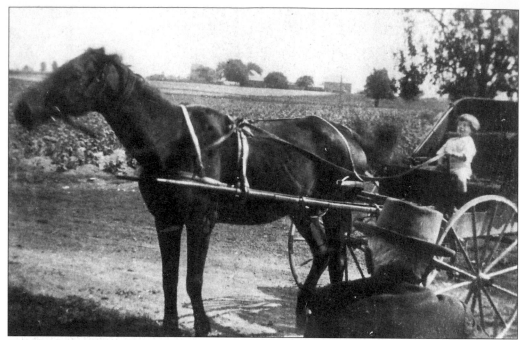

"Whoa, big fella!" That's what wide-eyed Ed Gorsuch might have been saying in this image from the summer of 1918. The youngster's grandfather, with his back to the camera, seems unconcerned. Significant here are the trees visible just above the horse's nose, on the grounds of the Stratman farm. It is here that British major general Robert Ross reportedly fell, mortally wounded by local militiamen, privates Daniel Wells and Henry McComas, on September 12, 1814. Ross's death, combined with Fort McHenry's defense, stunned the invaders into all-out retreat. (Courtesy Dundalk–Patapsco Neck Historical Society Museum.)

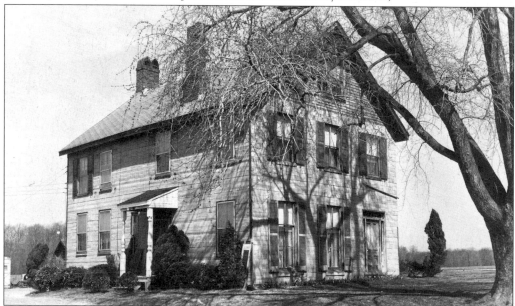

During their advance, British forces occupied this residence, the Shaw house, off North Point Road. (Courtesy Dundalk–Patapsco Neck Historical Society Museum.)

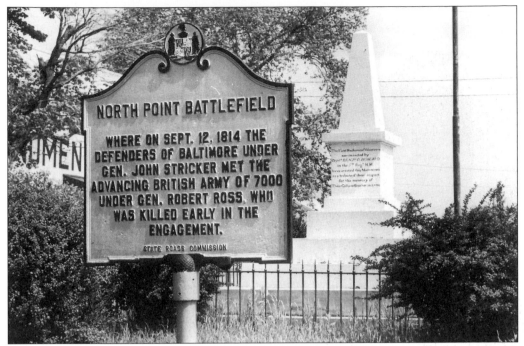

This marker and monument commemorate the spot where British forces advanced no farther. It is situated along what is now Old North Point Road, adjacent the Charlesmont neighborhood. (Courtesy Dundalk–Patapsco Neck Historical Society Museum.)

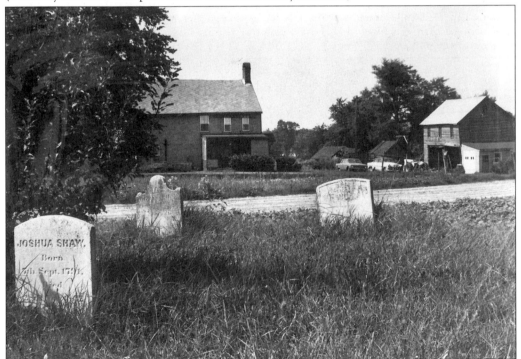

The Shaw family cemetery is visible in this image of the house, taken in the 1960s or 1970s. (Courtesy Dundalk–Patapsco Neck Historical Society Museum.)

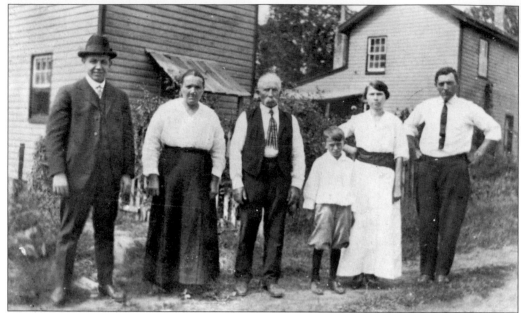

The Shaw house remained in the family for much of the 19th century. Elmer Stansbury, shown here at left, acquired the property around 1890. With him are, from left to right, Mary Pabich and her husband, Peter, who was a blacksmith and carpenter; Bernard Pabich; and Bernard's parents, Katherine and John Pabich, who was the farm's overseer. This photograph is from the early 20th century. (Courtesy Dundalk–Patapsco Neck Historical Society Museum.)

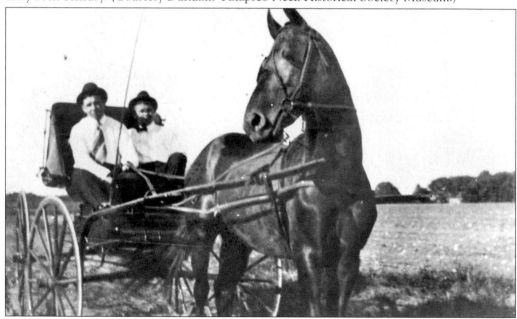

Stansbury (left) is shown here with friend Hall Hammond, an attorney, in a buggy on the grounds of the Shaw house. According to locals, the horse drawing the buggy—Stansbury's favorite—spooked during a thunderstorm not long after this photograph was taken. Running wildly across the grounds, it tried to leap a fence, was impaled, and had to be destroyed. (Courtesy Dundalk–Patapsco Neck Historical Society Museum.)

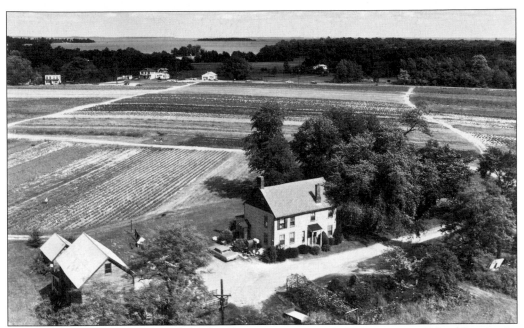

This aerial view of the Shaw house shows its proximity to Shallow Creek and the Chesapeake Bay in the background. The former Shaw property is now part of North Point State Park. (Courtesy Dundalk–Patapsco Neck Historical Society Museum.)

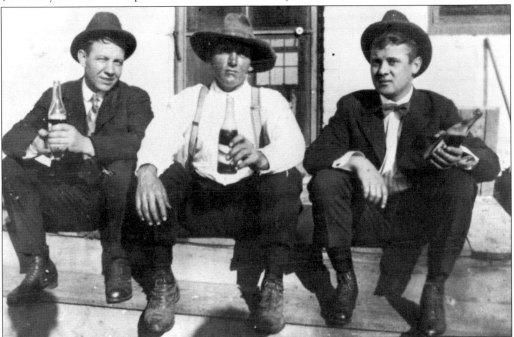

Elmer Stansbury (left), John Pabich (center), and Hall Hammond pose on the back porch of the Shaw house in the early 1900s with "the pause that refreshes." Judging by their attire, this may have been a Sunday. Stansbury owned the Shaw house until around 1925. The property was later acquired by Bethlehem Steel, which demolished the house in 1976. (Courtesy Dundalk–Patapsco Neck Historical Society Museum.)

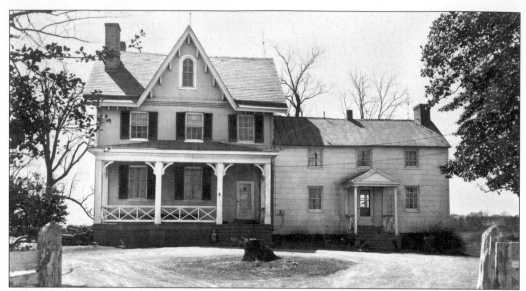

Perhaps the best-known landmark on "The Defender's Trail," as the peninsula is sometimes called, is the Todd house or Todd's Inheritance. During their retreat, the British burned the original house. The family immediately rebuilt this structure on the original foundation, with the same bricks from the original house. Formerly from Virginia, patriarch Thomas Todd settled here in 1664. His holdings, which would be passed on to 10 generations of Todd family members, once consisted of over 1,000 acres. Here they raised tobacco, grain, vegetables, and fruit with the help of slave labor. Two members of the Todd family were among the local militiamen who helped drive out British forces. (Courtesy Dundalk–Patapsco Neck Historical Society Museum.)

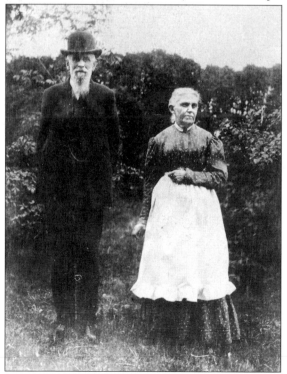

Members of the Todd family occupied Todd's Inheritance until 1970. Seen in this image from the late 19th century are Mr. and Mrs. Thomas B. Todd. Mr. Todd became a member of the Baltimore County School Board in 1894 and served as its president from 1900 to 1912. (Courtesy Dundalk–Patapsco Neck Historical Society Museum.)

The original Todd house featured a rooftop cupola. It was from that vantage point that militiamen first spotted the British ships and forces landing at North Point. The cupola was left off the new Todd house, which was completed in 1816. Porches were added during the Civil War, as were the attic dormer windows. (Courtesy Dundalk–Patapsco Neck Historical Society Museum.)

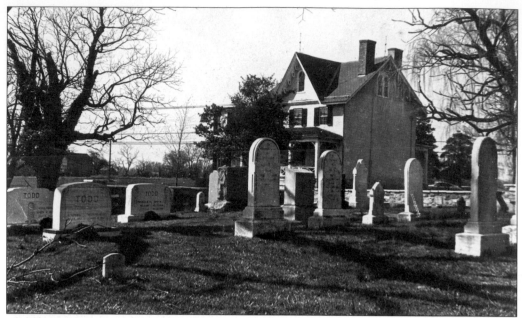

The region's first Presbyterian religious services were conducted at the Todd house in 1714. The family cemetery dates back to 1717. (Courtesy Dundalk–Patapsco Neck Historical Society Museum.)

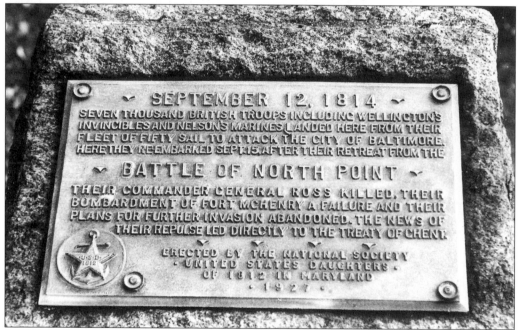

In 1793, Capt. Robert North sailed his ship, *Content*, to the location that is now Fort Howard, naming the point after himself. Previously a Native American trail, the road leading to and from Fort Howard today is called Old North Point Road. This plaque, dedicated in 1927, marks the spot where the British invasion began. Overshadowed by the events at Fort McHenry, the Battle of North Point and its significance have been all but forgotten, except by locals and military scholars. (Courtesy Dundalk–Patapsco Neck Historical Society Museum.)

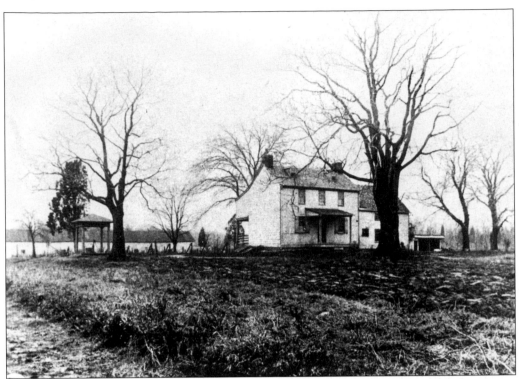

Dr. Trotten's house, occupied briefly by the British, was used by Sparrows Point Golf and Country Club a century later. The doctor and his wife fled prior to the occupation, and the house, while spared, was looted by the British. (Courtesy Dundalk–Patapsco Neck Historical Society Museum.)

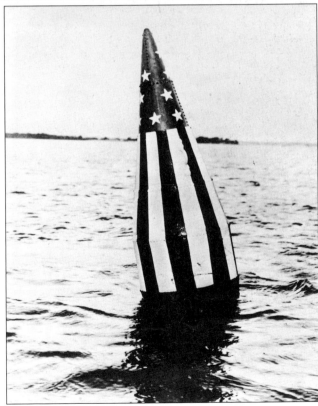

In the waters off of Dundalk where the Patapsco River meets Chesapeake Bay, this star-spangled buoy marks the approximate location of the British fleet that pummeled Fort McHenry. From this vantage point, Baltimore lawyer Francis Scott Key penned the words that would become "The Star Spangled Banner." (Courtesy Dundalk–Patapsco Neck Historical Society Museum.)

Another British-occupied home was the Gorsuch house. Situated on 242 acres, the house was built around 1806 on "Lynch's Discovery," land that once belonged to Patrick Lynch. Sparrows Point Golf and Country Club occupies the site today. It is said that General Ross ate breakfast here, then, when asked if he was returning for dinner, reportedly said, "I shall eat my next meal in Baltimore or in hell." He was killed a short time later among a grove of poplar trees, within sight of the Gorsuch house. (Courtesy Dundalk–Patapsco Neck Historical Society Museum.)

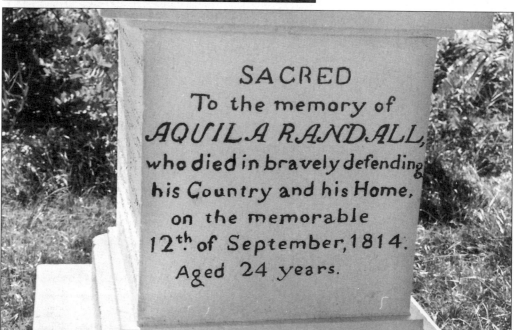

A close-up of the monument at Battle Acre on Old North Point Road memorializes Aquila Randall, believed to have been the first Maryland militiaman killed during the Battle of North Point. (Courtesy Dundalk–Patapsco Neck Historical Society Museum.)

Two

BUSINESS AND INDUSTRY

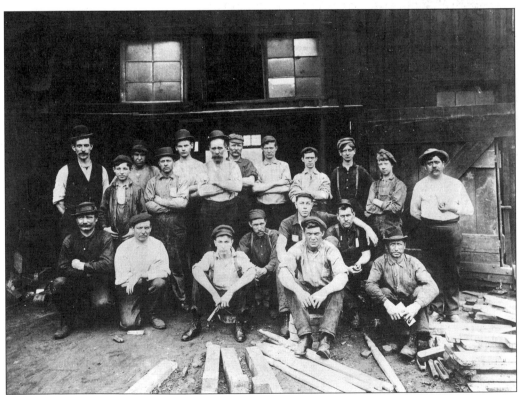

Laborers pose for this shot taken at Bethlehem Steel's Sparrows Point facility around 1920. Notice the youngsters in the group. The work was hard, dirty, and dangerous, requiring bravery, a strong back, and little else. (Courtesy Dundalk–Patapsco Neck Historical Society Museum.)

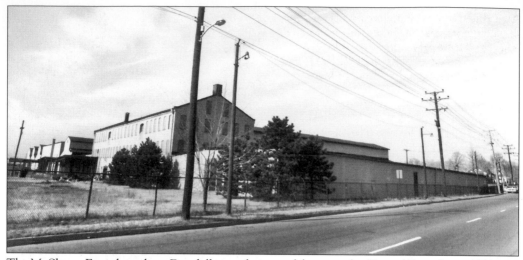

The McShane Foundry, where Dundalk was christened, became the Central Foundry in 1899, just four years after it was established. With new ownership, it operated until the 1940s. The buildings were demolished in 1981. (Courtesy Dundalk–Patapsco Neck Historical Society Museum.)

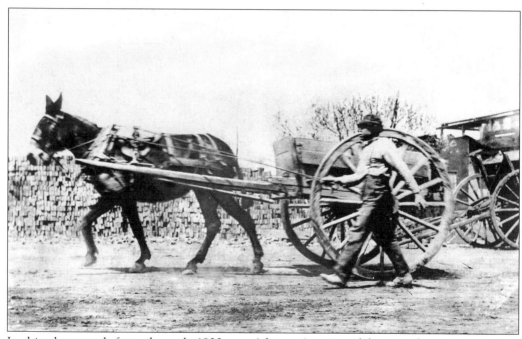

In this photograph from the early 1900s, an African American laborer is shown transporting bricks from the kiln to the loading dock at the Burns and Russell brickyard. Donkeys and carts were used for the heavy hauling. Workers were paid piecework for every 100 bricks loaded. Sailing ships then transported the bricks the short distance over water from Dundalk to Baltimore harbor. (Courtesy Dundalk–Patapsco Neck Historical Society Museum.)

Alex Russell IV poses before an Erie steam shovel digging clay at the Burns and Russell brickyard. Russell was 30 years old when he assumed control of the firm in 1900, about the same time this photograph was taken. Burns and Russell has been in the brick-making business since 1790, originally located around the present sites of M&T Bank Stadium and Oriole Park. Baltimore's Russell Street, which passes by the two sports facilities, is named for the firm. In 1885, they purchased 125 acres for $15,000 at what is now the Dundalk Marine Terminal, where they remained until about 1927. Production moved to North Point Road until fire completely destroyed the operation in 1941. Burns and Russell bricks were used for myriad Baltimore building projects, including Mount Clare Station, Johns Hopkins Hospital, Camden Station, the Shot Tower, and thousands of rowhouses. Today the firm produces Spectra Glaze products used in buildings all across America. (Courtesy Dundalk–Patapsco Neck Historical Society Museum.)

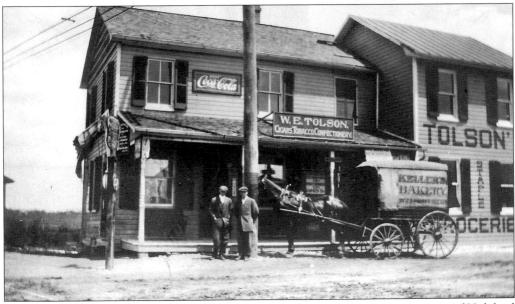

Two unidentified men pose in front of Tolson's Store at what is now the intersection of Holabird and Dundalk Avenues. The roads in those days were dirt and called Shell Road and New Pittsburgh Avenue. Wello Tolson was the store's owner. A horse and wagon from Keller's Bakery was probably delivering bread when this early-1900s photograph was snapped. The store was demolished in 1920 to improve Dundalk Avenue. (Courtesy Dundalk–Patapsco Neck Historical Society Museum.)

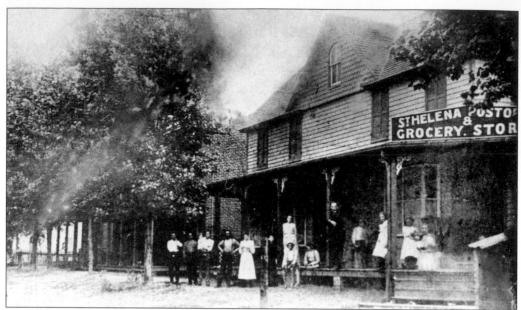

The region's first rail service was established in 1882. Among other things, it delivered the mail to St. Helena, as the area was then known. Delivered isn't exactly the right word, since mailbags were tossed from trains as they passed Baltimore Avenue. In 1897, the local post office moved from a private home to Spencer's Store, at Baltimore and Railroad Avenues, where it remained until 1908, when the store burned down. This photograph is believed to be from 1897. (Courtesy Dundalk–Patapsco Neck Historical Society Museum.)

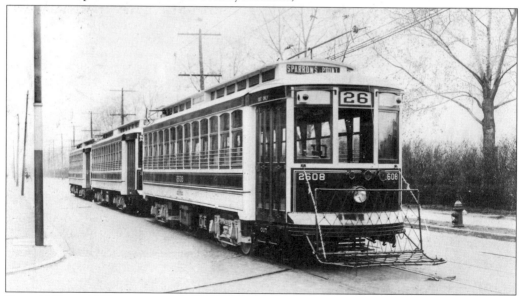

From 1903 to 1958, streetcars called "Red Rockets" made their way up and down Dundalk Avenue, between Baltimore and Sparrows Point. This "triple header," photographed in the 1920s, was operated by the United Railway and Electric Company, forerunner to the Baltimore Transit Company, and it came complete with a cow-catching device in the event of an encounter with stray livestock. Four such streetcars can be seen today at the Baltimore Streetcar Museum. (Courtesy Dundalk–Patapsco Neck Historical Society Museum.)

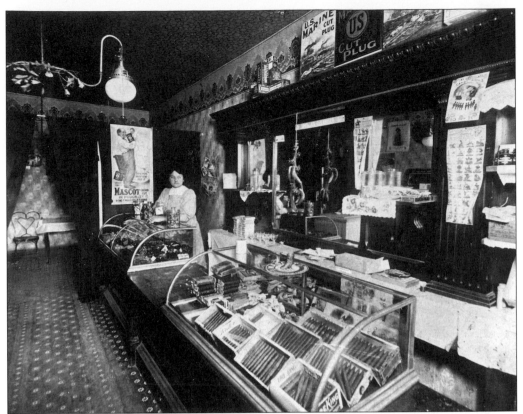

In this image from 1913, Marian Rumph Zang poses behind the counter of her Sparrows Point store, which featured ice cream, tobacco, and candy. (Courtesy Dundalk–Patapsco Neck Historical Society Museum.)

If this, the original location of Norris Ford, looks familiar, there is good reason. It has been the Pinland bowling center on Dundalk Avenue for more than 50 years. Look closely and you'll see a couple of old gasoline pumps on either side of the entrance. The Grace farm is visible at the rear left in this shot from the 1920s. (Courtesy Dundalk–Patapsco Neck Historical Society Museum.)

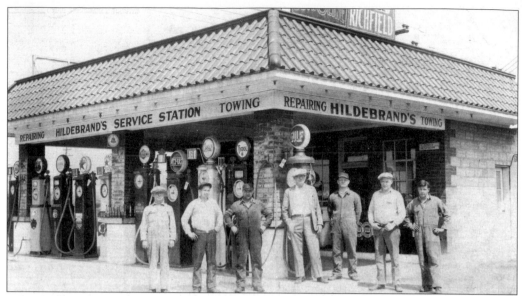

Like most service stations of the early 20th century, Hildebrand's Garage, on what is now Holabird Avenue, carried many different brands of gasoline—10 to be precise. (Courtesy Dundalk–Patapsco Neck Historical Society Museum.)

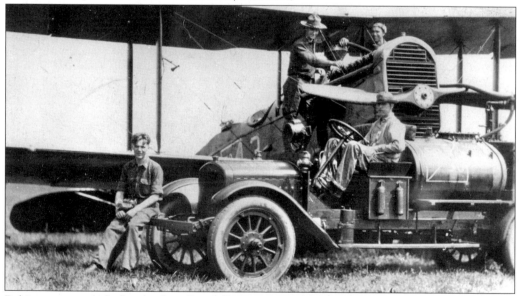

Baltimore aviation had its birth in Dundalk. In 1916, Bethlehem Steel paid a whopping $1,200 per acre for a level tract of farmland near the current site of Logan Village. In 1919, they allocated 100 acres for a flying field to be called "The Dundalk Airdrome." On July 5, 1920, army pilot Lt. Patrick Logan, the greatest stunt pilot of his day, was to perform "acts of daring." Leveling off at 2,000 feet, Logan placed his "Red Devil" biplane into a tail spin but was unable to pull out before crashing into a nearby cornfield. Rushed to Johns Hopkins Hospital, Logan died on the operating table. Some time later at the formal dedication of the field, army general William "Billy" Mitchell and Baltimore mayor William Broening announced that the site would be renamed Logan Field in his memory. In this photograph from around 1930, unidentified Maryland Air National Guardsmen prepare to fuel a biplane. (Courtesy Dundalk–Patapsco Neck Historical Society Museum.)

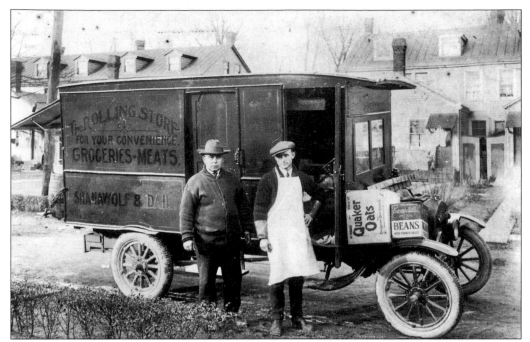

Here is an example of American ingenuity—1920s style. Long before anyone dreamed of a convenience store, these two gents, Messrs. Shanawolf and Dail, found a way to bring the store to shoppers. The Rolling Store featured general grocery items and meats. They stopped on Shipway long enough to pose for this undated picture. (Courtesy Dundalk–Patapsco Neck Historical Society Museum.)

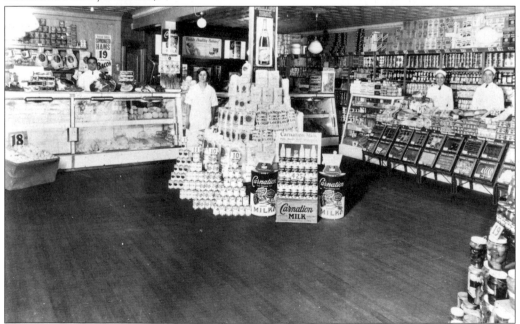

The GA Store on Holabird Avenue appears well stocked and neat as a pin in this image from the 1920s or 1930s. On this day, smoked hams sold for 19¢ a pound, while four cans of Carnation Milk went for a quarter. (Courtesy Dundalk–Patapsco Neck Historical Society Museum.)

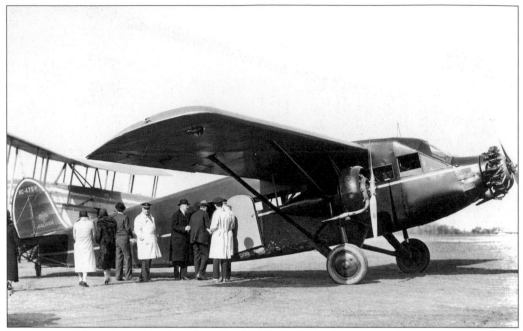

Passengers and crew are seen boarding this Luddington Air Line monoplane at Logan Field on March 8, 1931. C. T. Luddington founded the line, which offered service between Washington, Baltimore, Philadelphia, and New York in 1930. His vice president was Amelia Earhart, who later paid a visit to Logan Field. Luddington would merge with Eastern Airlines in 1933. (Courtesy Baltimore County Public Library.)

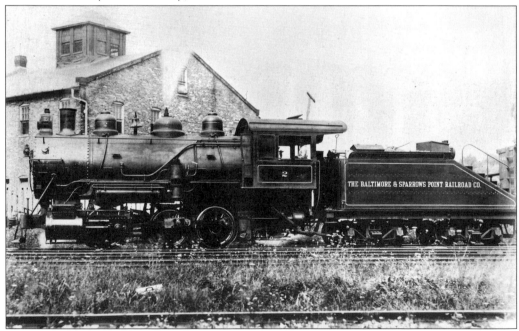

The Baltimore & Sparrows Point Railroad engine and tender No. 2 are hard at work at Bethlehem Steel in this undated photograph. (Courtesy Dundalk–Patapsco Neck Historical Society Museum.)

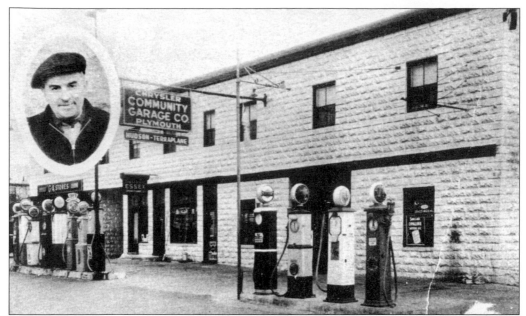

Italian immigrant Flaminio Rossi opened Rossi's Community Garage on Willow Spring Road in the St. Helena neighborhood in 1922. No less than a dozen different gas pumps can be seen in this early photograph. The garage also advertised service for now defunct auto brands like Hudson, Essex, and Plymouth. And although the gas pumps are long gone, the building still serves as a garage today. (Courtesy Dundalk–Patapsco Neck Historical Society Museum.)

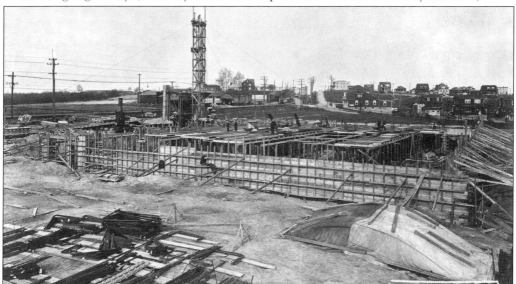

Food processor Crosse and Blackwell was established in Great Britain in 1706. This photograph, from April 18, 1927, shows their new facility under construction on Eastern Avenue, at the city/county line. The first Crosse and Blackwell plant in America, it treated neighbors to a variety of unique aromas including apples, ketchup, and pickles. In this view looking east, traffic can be seen on Eastern Avenue. The Harbor View neighborhood appears on the right. And in the background on the left, farmhouses stand in the area that would become Eastwood 26 years later. (Courtesy Dundalk–Patapsco Neck Historical Society Museum.)

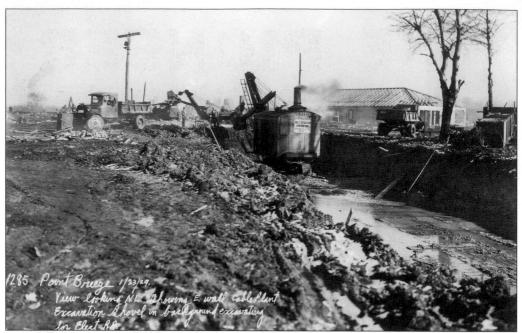

On January 23, 1929, the last remnants of Riverview Park are making way for construction of a new plant for Western Electric. The site had long been a center for entertainment and amusement. Beginning in 1868, there was "Lowrey's Place on Colgate Creek," a local beer garden. Sixty acres were leased eight years later for Point Breeze, a resort that exploited the gentle breezes coming off the bay. Rides and concessions were added later, and in 1898, it became Riverview Park, "the Coney Island of the South." Despite its popularity, by 1929 it was rubble. (Courtesy Dundalk–Patapsco Neck Historical Society Museum.)

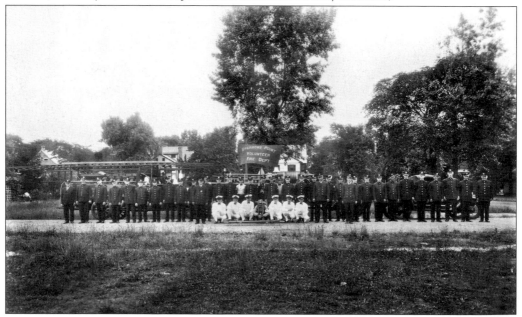

Members of the Sparrows Point Volunteer Fire Department posed for this photograph on June 13, 1930. (Courtesy Dundalk–Patapsco Neck Historical Society Museum.)

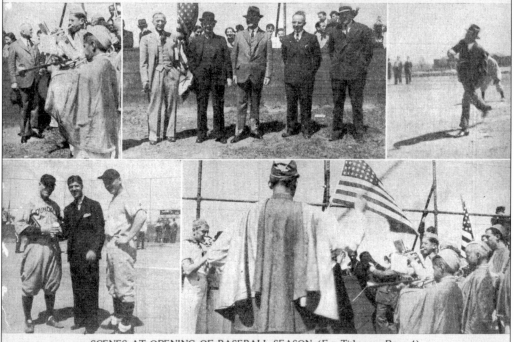

THE PIONEER

A NEWS MAGAZINE

——— FOR ———

Dundalk	**St. Helena**
Lorraine Park	**Edgemere**

Sparrows Point

SCENES AT OPENING OF BASEBALL SEASON (For Titles see Page 4)

Vol. 1 **MAY 6, 1938** No. 5

One of the first local Dundalk publications was *The Pioneer*. It debuted in 1938. Over the years, community news sources included *The Dundalk Times, The Community Press and Baltimore Countian,* and *The Dundalk Eagle.* Of them, only the *Eagle,* a weekly paper founded by the late Kimbel Oelke, survives. (Courtesy Dundalk–Patapsco Neck Historical Society Museum.)

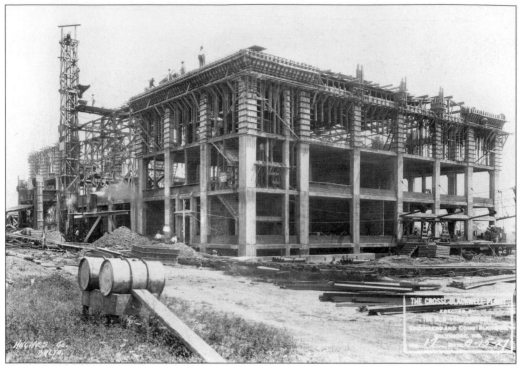

Construction is progressing on the new Crosse and Blackwell plant, as evidenced in this photograph from August 15, 1927. This was one British invasion Dundalk didn't mind. While the Crosse and Blackwell brand name still exists, the Eastern Avenue facility shut down years ago, and the building disappeared altogether in the 1990s. (Courtesy Dundalk–Patapsco Neck Historical Society Museum.)

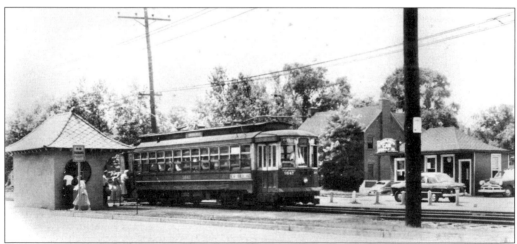

Streetcars were vital to the economy of early Dundalk, as privately owned automobiles did not become commonplace until the second half of the 20th century. Passengers here are boarding at the Dundalk station. In the background to the right is the Community Cab Company, one of several transportation-related businesses operated by Dundalk businessman Ted Graff. (Courtesy Dundalk–Patapsco Neck Historical Society Museum.)

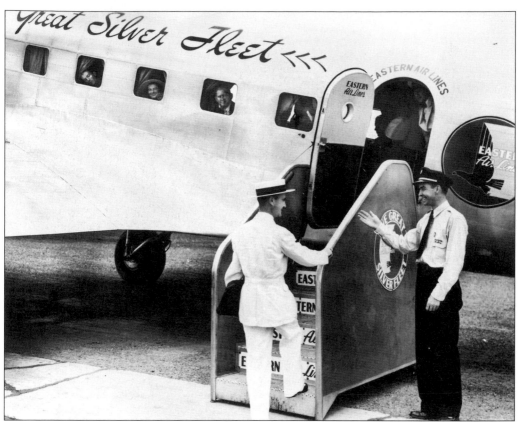

It is a summer day in the 1930s, and the final passenger boards this Eastern Air Lines DC-3 at Logan Field. Passenger air travel was in its infancy, and Eastern, established in 1928, was among the first carriers to serve Baltimore.

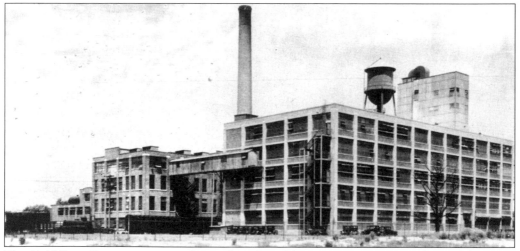

The Gold Dust Corporation manufactured products like Rinso, Fairy Soap, and Lux Flakes from this Holabird Avenue plant acquired by Lever Brothers in 1939. The facility is still in operation today. (Courtesy Dundalk–Patapsco Neck Historical Society Museum.)

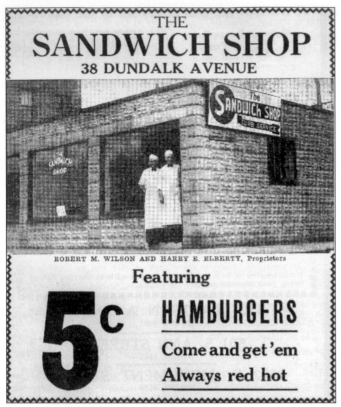

THE
SANDWICH SHOP
38 DUNDALK AVENUE

ROBERT M. WILSON AND HARRY E. ELBERTY, Proprietors

Featuring

5¢ HAMBURGERS

Come and get 'em
Always red hot

Hungry? Long before Gino's, the Little Tavern, Ameche's, or Captain Harvey's, you could get "red hot" burgers at the Sandwich Shop on Dundalk Avenue for a nickel. This ad appeared in *The Pioneer* in May 1938. (Courtesy Dundalk–Patapsco Neck Historical Society Museum.)

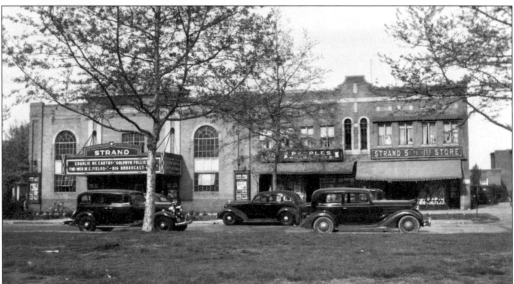

Radio superstar Charlie McCarthy in *The Goldwyn Follies* is on the marquee of the Strand in this photograph from 1938. Next door are Peoples Drug Store and the Strand 5 and 10 Cent Store. W. C. Fields in *The Big Broadcast of 1938* is shown as the next film coming to the Strand. Those old enough to remember the classic radio feuds of Fields and McCarthy will recall that they were among the funniest in radio's golden age. (Courtesy Dundalk–Patapsco Neck Historical Society Museum.)

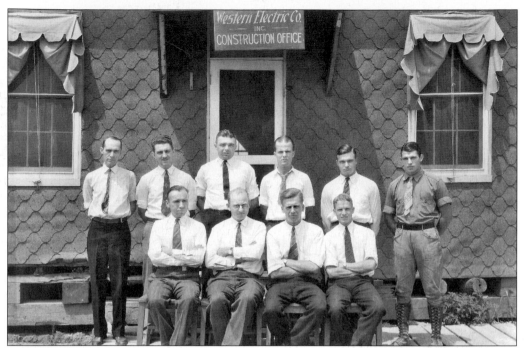

The staff of the Western Electric construction office took time out to pose for this photograph on August 7, 1929. (Courtesy Dundalk–Patapsco Neck Historical Society Museum.)

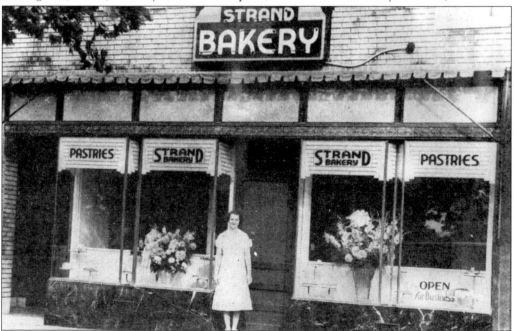

If you were hungry for something sweet, the Strand Bakery was your destination of choice. Taking its name from the theatre next door, it supplied baked goods to the Poplar Inn, the Airport Grill, and other area eateries. It later opened additional stores in Essex and Watersedge. Mrs. Carl Habicht, wife of the owner, is seen in this shot from October 21, 1938. The bakery closed in 1971. (Courtesy Dundalk–Patapsco Neck Historical Society Museum.)

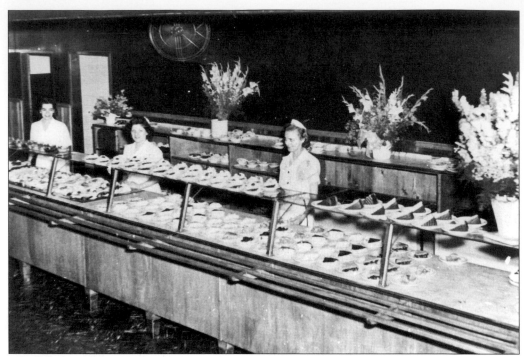

The Western Electric Company boasted a fine employee cafeteria at its Point Breeze facility on Broening Highway. In this undated photograph believed to be from the 1940s, uniformed workers are surrounded by a variety of tempting dessert items that make one think, "Let them eat cake!" (Courtesy Dundalk–Patapsco Neck Historical Society Museum.)

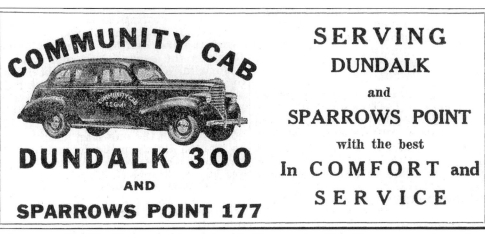

Businessman Ted Graff placed this ad for his Community Cab Company in the spring of 1938. A highly successful entrepreneur, Graff was a fourth-grade dropout who gave back to the community by sponsoring youth athletic teams. (Courtesy Dundalk–Patapsco Neck Historical Society Museum.)

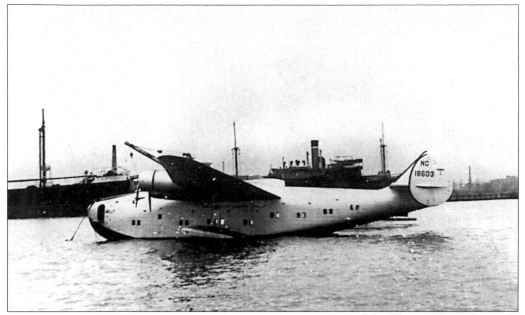

Pan American Airlines' "flying boats," the famous Clippers, began operating from a seaplane terminal near the present-day Dundalk Marine Terminal in the late 1930s. Offering luxurious standards for the day, they carried up to 60 passengers to Bermuda (five hours away) twice a week. Civilian service was suspended during World War II, and Pan Am moved most of its Clippers to New York, transferring three ships to the British Overseas Airways Corporation (BOAC). BOAC was the forerunner to today's British Airways and used the seaplanes primarily for war-related purposes. British Prime Minister Winston Churchill departed Dundalk's Harbor Field on a BOAC flight in 1942. (Courtesy Dundalk–Patapsco Neck Historical Society Museum.)

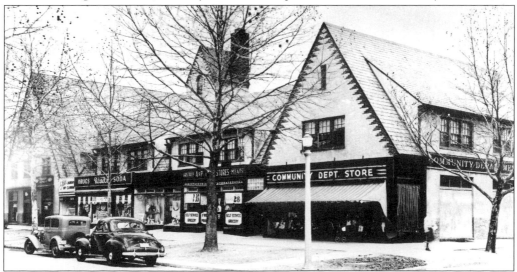

If Dundalk had a downtown, it would be the Dundalk Village Shopping Center. The original commercial core of the community, it was completed in 1919 and recently received the "Mainstreet Maryland" designation, which acknowledges its historical importance and increases the likelihood of state funding. This image is from the 1930s. (Courtesy Dundalk–Patapsco Neck Historical Society Museum.)

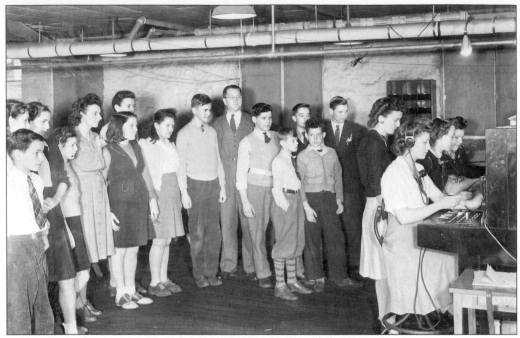

When fire displaced the Sparrows Point telephone exchange in the 1940s, it temporarily relocated to the basement of Sparrows Point High School. Here a group of well-dressed students on their best behavior (their teacher and principal were also there) observe the operators at work as they answer, "Number, please." (Courtesy Dundalk–Patapsco Neck Historical Society Museum.)

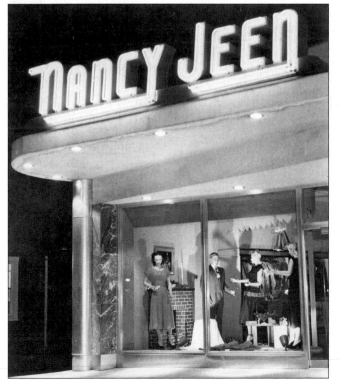

Ted Graff's wife, Juanita, owned the Nancy Jeen clothing store on Dundalk Avenue, named after the couple's daughter. Now closed, it is seen here in a photograph from 1949. (Courtesy Dundalk–Patapsco Neck Historical Society Museum.)

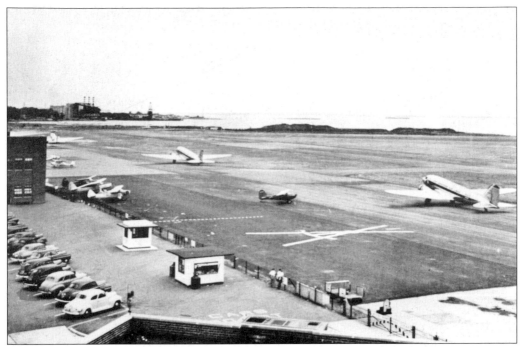

With Bethlehem Steel and Chesapeake Bay in the background, planes prepare to take off from Harbor Field in the late 1940s. (Courtesy Dundalk–Patapsco Neck Historical Society Museum.)

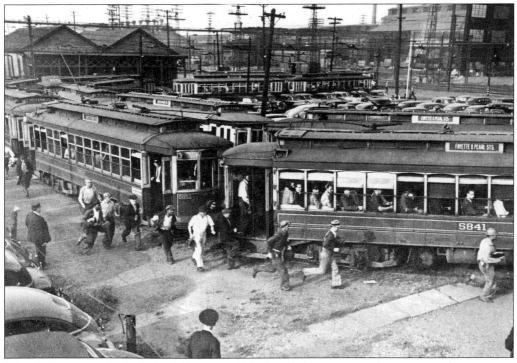

It's quitting time at "The Point" (Sparrows Point), and the race is on for a seat on the streetcar, as this undated image captures a shift change at Bethlehem. (Courtesy Dundalk–Patapsco Neck Historical Society Museum.)

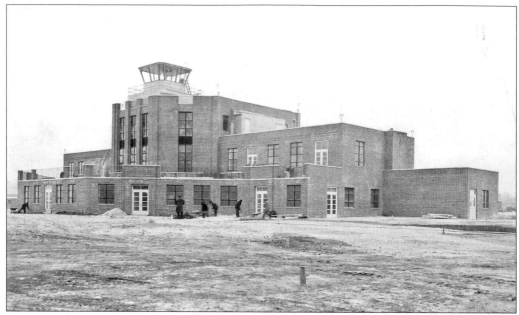

Harbor Field's terminal building is nearly complete in this shot from March 1941. Built by the City of Baltimore to replace Logan Field, the new airport was not without its problems. First the war interrupted civilian travel. Then portions of runways, which were already too short, cracked and sunk as backfill material settled. Harbor Field's tenure as Baltimore's municipal airport would be brief, lasting only until 1950, when Friendship (now BWI) opened. But Harbor Field remained in service for private planes until 1960. The old terminal building finally came down in 2005. (Courtesy Dundalk–Patapsco Neck Historical Society Museum.)

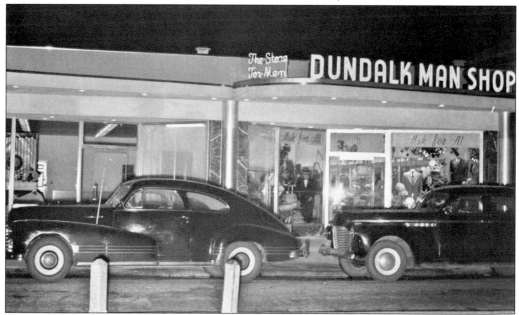

The sign in the window of the Dundalk Man Shop in the Dundalk Village Shopping Center encourages the shopper to "Ask for Al." (Courtesy Dundalk–Patapsco Neck Historical Society Museum.)

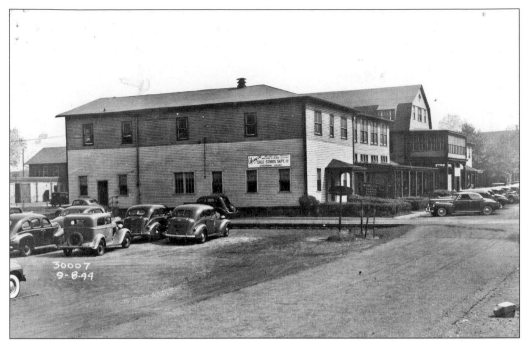

The Bethlehem Steel Company Store promised "Sensational Values" at their closeout sale, as seen in this photograph from September 8, 1944. Judging by the number of parked cars, business must have been brisk. (Courtesy Dundalk–Patapsco Neck Historical Society Museum.)

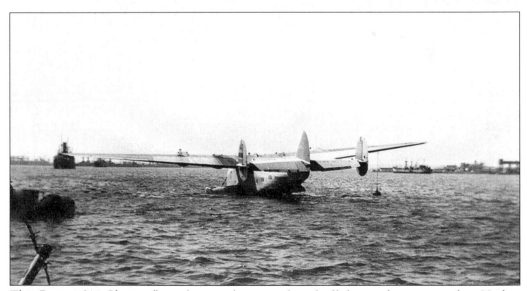

This Boeing 314 Clipper flying boat is shown anchored off the seaplane terminal at Harbor Field in 1948. (Courtesy William and Colin Ebert.)

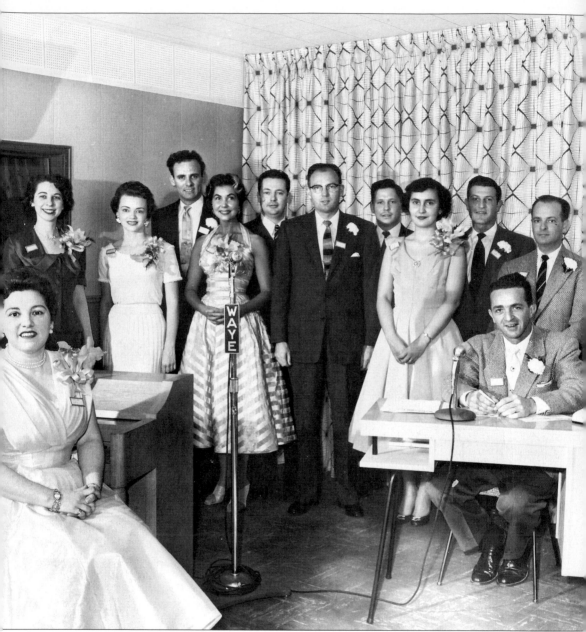

Guy Erway owned and presided over WAYE 860 AM, which signed on the air in 1955 from studios located in the Dunleer Building. The woman seated far left at the piano is unidentified. The remaining people were, from left to right, Winnie Phillips, Miss Maryland 1954 Phyllis Leftwich (the only Miss Maryland to come from Dundalk), Ted Barnes, Florence Johnson, Harry Phillips, Guy Erway, Walter Nawrocki, Dorothy Ellis, unidentified, Marv Chessler, and Bud Roberts. Over the years, WAYE featured big band music and album rock. The station moved to Baltimore in 1960. Today 860 AM is WBGR and features religious programming. (Courtesy Dundalk–Patapsco Neck Historical Society Museum.)

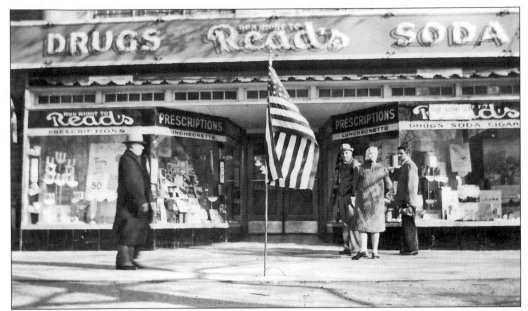

"Run Right to Read's" was a slogan familiar to all locals during the early and middle 20th century. Locally owned, the Read's drugstore chain featured stores all over metropolitan Baltimore. Dundalk was no exception, as evidenced by this location in Dundalk Village Shopping Center on Shipping Place. (Courtesy Dundalk–Patapsco Neck Historical Society Museum.)

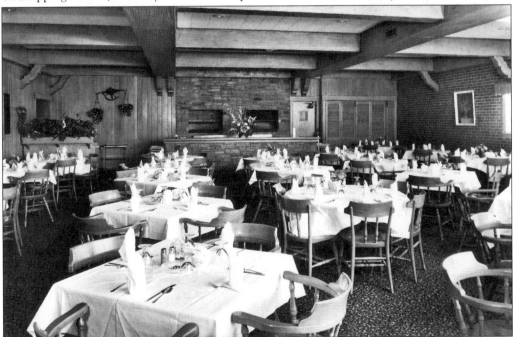

Karson's Restaurant enjoyed the benefits of being located next to Lever Brothers, across the street from American Standard and General Motors, and about a mile from Fort Holabird, Western Electric, and the big Esso facility in Canton. Karson's began serving lunch and dinner in 1926 at Holabird Avenue and Poncabird Pass. The restaurant closed in 1999, and the building has since been demolished. (Courtesy Dundalk–Patapsco Neck Historical Society Museum.)

Just try running a classified ad today like this one from 1955, posted by radio station WAYE. (Courtesy Dundalk–Patapsco Neck Historical Society Museum.)

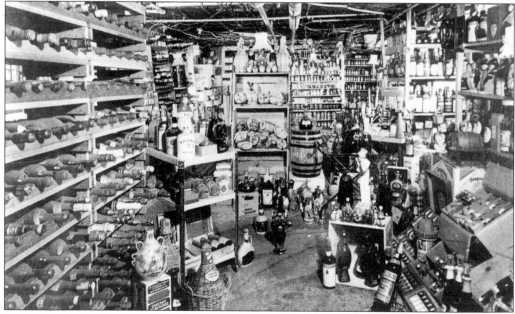

Shown here is the famous wine cellar of the Brentwood Inn. Here diners could sample fine wines and liqueurs in the cramped, dusty surroundings. (Courtesy Baltimore County Public Library.)

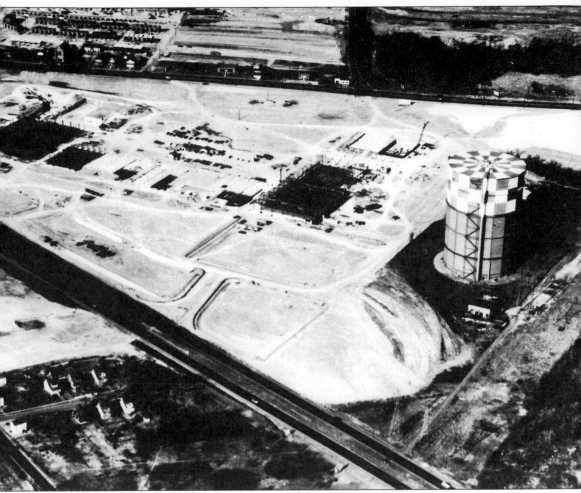

The mid-1950s saw construction begin on Dundalk's first big shopping center. When Eastpoint opened in 1956 at the intersection of Eastern Avenue and North Point Road, it featured local retailers like Hochschild Kohn and Hutzler's; grocery stores such as Food Fair and Penn Fruit; and specialty shops like Arundel Ice Cream, G. C. Murphy, Fair Lanes, and Bishop's Holiday House, a pet store. Additional stores were constructed in the early 1960s and included Brookwood Farms, Silber's Bakery, Pilgrim House Furniture, and local men's clothing chain Hamburger's. The mall was enclosed in the 1970s. But the most unique things about Eastpoint's early days had nothing to do with shopping. Long before the National Aquarium at Baltimore was ever conceived, Hochschild's featured a corner window display of live penguins swimming about in a tank of presumably cold water. Equally entertaining was "Monkeytown," a window full of the little primates at Hess Shoes. The nearby landmark, a checkered natural gas tank, was erected in 1948 and was dismantled in 1984. The aircraft-warning beacon that was perched on its top was salvaged and can now be seen at the Dundalk–Patapsco Neck Historical Society Museum. (Courtesy Dundalk–Patapsco Neck Historical Society Museum.)

Brentwood Inn Features
SEAFOOD DINNERS FOR LENT

This 1956 advertisement for the Brentwood Inn offers a wide selection of seafood dinners "served complete with 2 garden-fresh vegetables, fresh Chef's salad, hot rolls and butter." Notice the most expensive menu item, Maryland Snapper Terrapin, went for just $3. (Courtesy Dundalk–Patapsco Neck Historical Society Museum.)

The Kresge's store on Shipping Place was a favorite destination of both kids and adults for decades. Holiday decorations adorn the Dundalk Village Shopping Center in this image from the late 1950s. (Courtesy Dundalk–Patapsco Neck Historical Society Museum.)

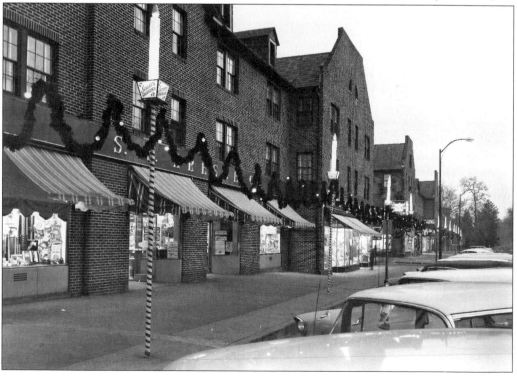

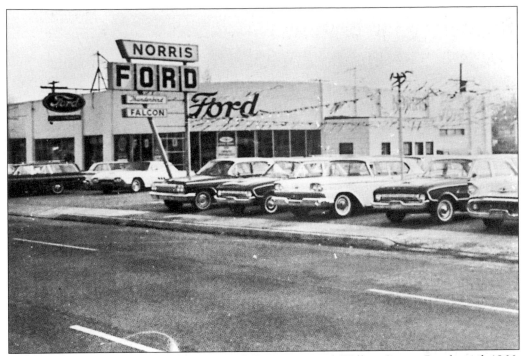

Norris Ford occupied this corner at Dundalk Avenue and Willow Spring Road until 1966, when they moved to their current and much larger location on Merritt Boulevard. (Courtesy Dundalk–Patapsco Neck Historical Society Museum.)

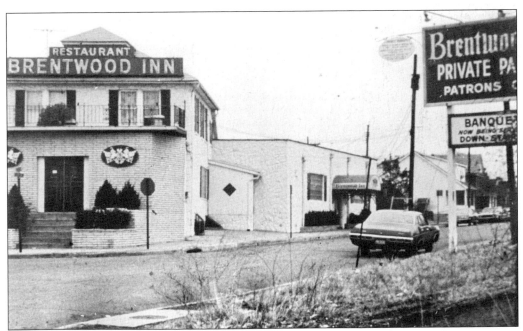

The Brentwood Inn was still featuring its "Fabulous Smorgasbord" when this photograph was snapped around 1970, but the popular restaurant's better days were already behind it. (Courtesy Dundalk–Patapsco Neck Historical Society Museum.)

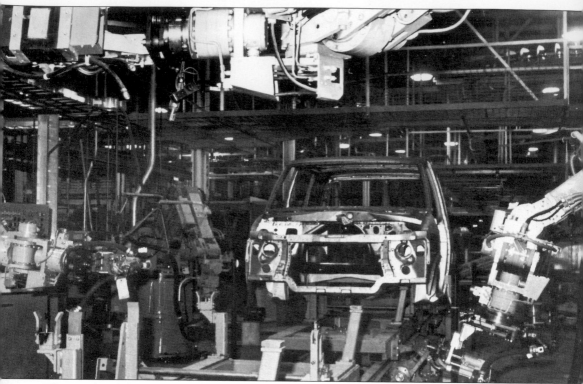

The inside of the General Motors plant at Holabird Avenue and Broening Highway is shown here. Opened in 1935, the massive facility once operated two shifts per day. In 1984, the Dundalk facility began producing only Chevrolet Astro and GMC Safari vans. As sales dropped off, GM cut back to just one shift per day in 2000. Competition from imports and the rising cost of health care benefits were among the reasons given when it was announced the Dundalk plant would close. As luck would have it, the last vehicle rolled off this assembly line on Friday the 13th—May 13, 2005. (Courtesy Dundalk–Patapsco Neck Historical Society Museum.)

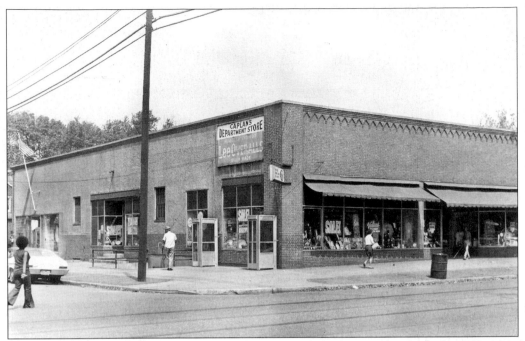

Caplan's Department Store rebuilt after a devastating 1945 fire. But by the early 1970s, time was running out for everyone in Sparrows Point. (Courtesy Dundalk–Patapsco Neck Historical Society Museum.)

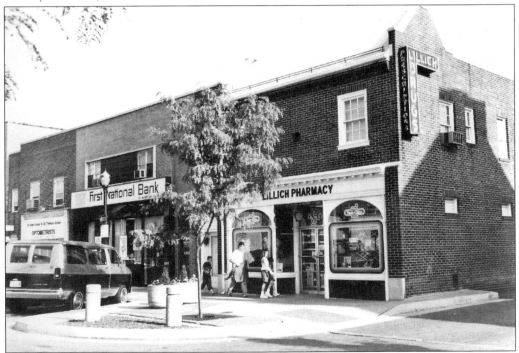

Lillich Pharmacy opened in the 1920s and moved to this site on Center Place in the 1940s. Anna Lillich co-owned the drug store with pharmacist Calvin Hunter when this photograph was taken in the 1980s. (Courtesy Dundalk–Patapsco Neck Historical Society Museum.)

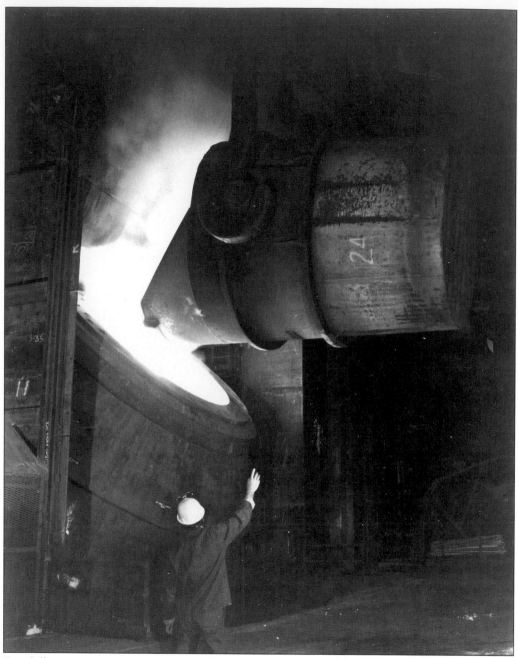

Dundalk owes its existence to steel. This photograph, from April 28, 1994, shows molten iron being poured into a vessel at Bethlehem Steel in Sparrows Point. Bethlehem purchased the Sparrows Point property from Maryland Steel, a subsidiary of Pennsylvania Steel, in 1916. (Courtesy Dundalk–Patapsco Neck Historical Society Museum.)

Three

NEIGHBORS AND NEIGHBORHOODS

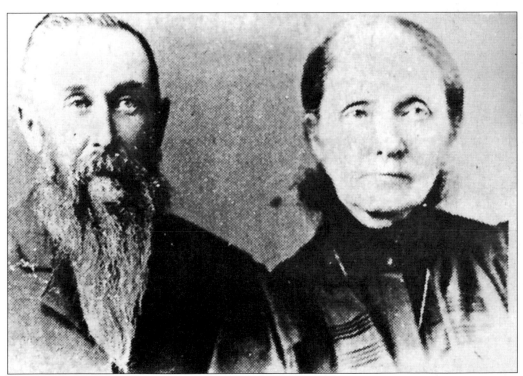

Capt. and Mrs. William Fitzell, shown here in a photograph from the late 19th century, were the last private owners of the Sparrows Point land that would become Bethlehem Steel. The Fitzells farmed the property before selling out to the Pennsylvania Steel Company in 1887. That single real estate transaction led to the development of Dundalk. (Courtesy Dundalk–Patapsco Neck Historical Society Museum.)

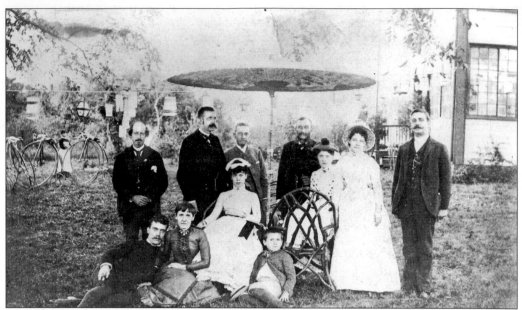

In 1733, Lord Baltimore granted Philip Jones a track of land along Welshman's Creek (now Jones Creek) in "Sparrow's Nest," as the area was then known. On that land, Thomas Jones constructed Walnut Grove in 1786. The home was so large and impressive that British forces planned on using it as a hospital during the Battle of North Point. In this photograph, members of the Jones family pose at a centennial celebration in 1886. Notice the high-wheeler bicycles in the background. (Courtesy Dundalk–Patapsco Neck Historical Society Museum.)

The community of Gray Manor began to emerge in the 1920s. Prior to development, Goldie Gray's family operated a farm near present-day Oakwood Road. (Courtesy Dundalk–Patapsco Neck Historical Society Museum.)

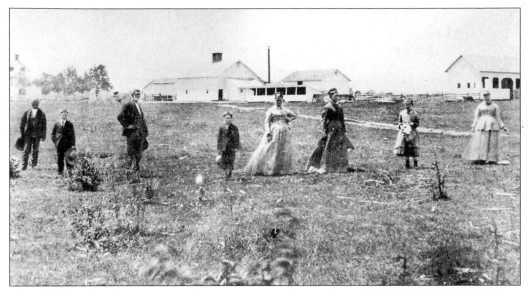

Before it became Stansbury Park and the community of Stanbrook, the area near present-day Merritt Boulevard and Peninsula Highway belonged to the Dorretts. George Thomas Dorrett and his family farmed the land and lived on the property from 1888 to 1945. The house, later abandoned, was burned for a fire department training exercise in 1993. Family members are seen here walking about the property in the late 19th century. (Courtesy Dundalk–Patapsco Neck Historical Society Museum.)

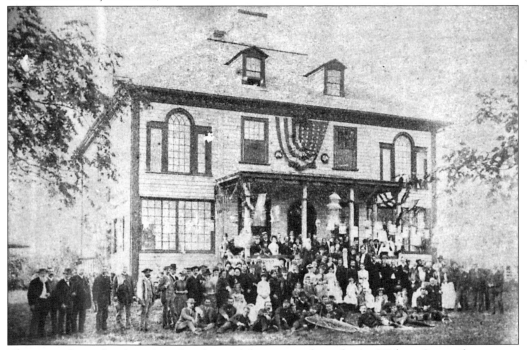

The entire Jones family gathered in front of their magnificent home, Walnut Grove, for a group photograph capping off their centennial celebration in 1886. For the family of means, the day's festivities even included a hot-air balloon ascension. (Courtesy Dundalk–Patapsco Neck Historical Society Museum.)

W. A. Gorsuch, shown here around 1900, served as police marshal for Baltimore County from 1909 to 1913. His office was in Canton, which was part of the county at the time, and he oversaw some 60 officers. Born in 1867, he lived most of his life at the Gorsuch house off Old North Point Road, where he also farmed. He died in 1950 at age 83 and is buried at Oak Lawn Cemetery on Eastern Avenue. (Courtesy Dundalk–Patapsco Neck Historical Society Museum.)

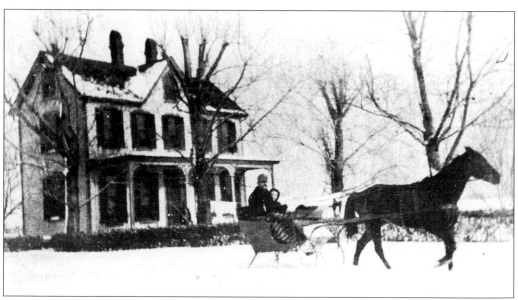

"Oh what fun it is to ride in a one-horse open sleigh!" A man, believed to be George Thomas Dorrett, and a child pass in front of the Dorrett farmhouse near what is now Stansbury Road on a snowy day around 1900. (Courtesy Baltimore County Public Library.)

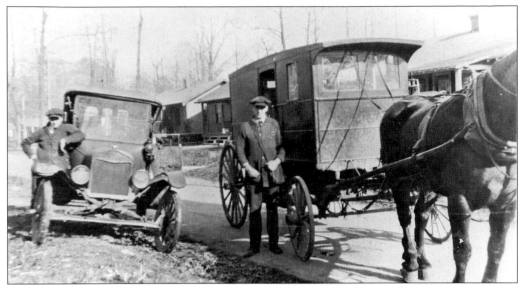

On a cool morning in 1922, David W. Spencer (with the car) and Mr. Powell (alongside the horse and wagon) are delivering fresh milk to residents of Sparrows Point. The earliest records available indicate that 3,000 acres were titled to Thomas Sparrow in 1652 and designated Sparrow's Nest. The last private owners were Mr. and Mrs. William Fitzell, who operated a farm and peach orchard here. Pennsylvania Steel bought out the Fitzells in 1887, and the first two dozen cottages were built later that year. By 1893, Sparrows Point would consist of 600 buildings, including churches and schools accommodating 400 children. The population exceeded 5,000 around 1905. (Courtesy Dundalk–Patapsco Neck Historical Society Museum.)

515 S. Broadway,
BALTIMORE. MD.

Until the 1920s, Ella Gray's family farmed 140 acres of what is now Gray Manor. (Courtesy Dundalk–Patapsco Neck Historical Society Museum.)

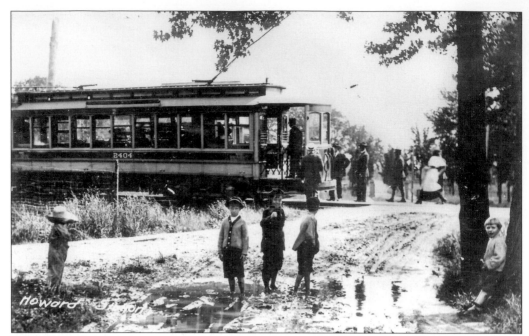

It must have been an exciting moment for these Fort Howard youngsters, as they had to decide whether to look at the streetcar or "watch the birdie" as their picture was taken. Though undated, this photograph appears to be from the early 1900s. (Courtesy Dundalk–Patapsco Neck Historical Society Museum.)

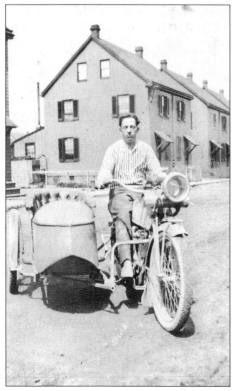

With 21st-century gasoline prices what they are, a motorcycle and sidecar wouldn't be such a bad idea today. Here Ike Miller stops long enough to pose along a street in Sparrows Point in 1916. (Courtesy Marcee Zakwieia.)

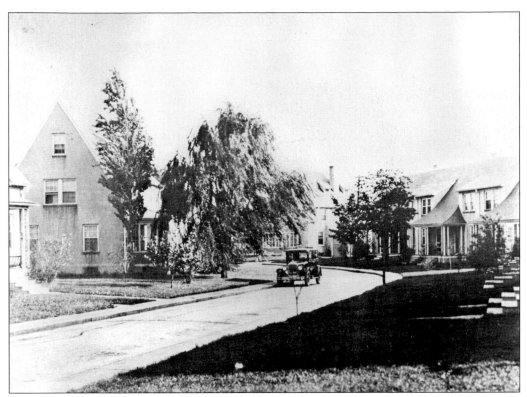

Parking wasn't an issue in the Dundalk of the 1920s (above). Nor was it much of a problem for St. Helena residents (below). Such is not the case today. (Courtesy Baltimore County Public Library.)

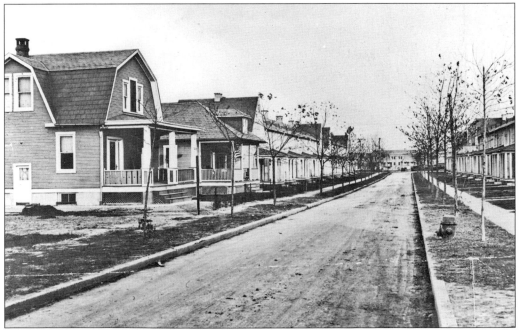

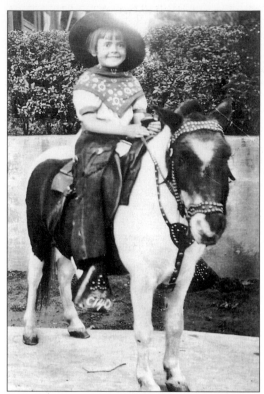

Wide-eyed little Carolyn Miller dresses the part for a pony ride outside of her E Street home in Sparrows Point around 1935. A lifetime resident of the area, she would serve on the Dundalk Centennial Committee 60 years later. (Courtesy Marcee Zakwieia.)

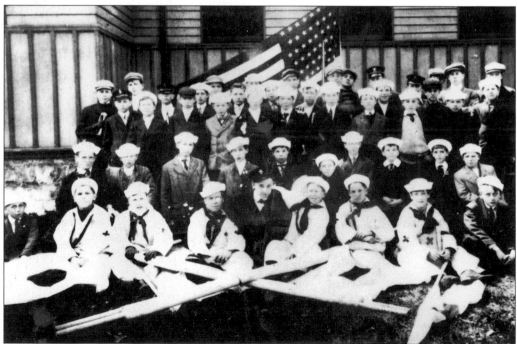

For more than a century, scouting has been a popular activity and guiding force for tens of thousands of Dundalk-area youth. This photograph, from around 1910, shows a gathering of the Sea Scouts in Sparrows Point. (Courtesy Dundalk–Patapsco Neck Historical Society Museum.)

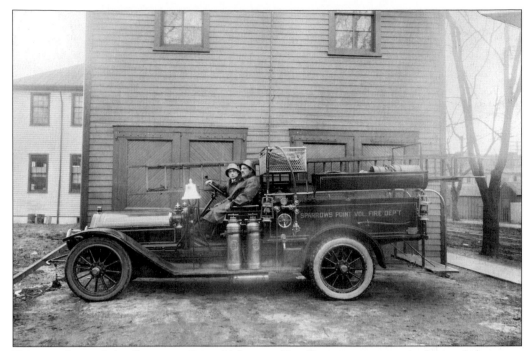

Two members of the Sparrows Point Volunteer Fire Department pose in front of the town firehouse around 1915. (Courtesy Dundalk–Patapsco Neck Historical Society Museum.)

Flaminio Rossi's Community Garage on Willow Spring Road was truly a family business, as evidenced by this photograph from the early 1930s. Rossi's daughters Lucy (left) and Margaret (right) are busy adding gasoline and water to a customer's car. A third daughter, Joan, can be seen in the middle, beside the White Flash gas pump. (Courtesy Dundalk–Patapsco Neck Historical Society Museum.)

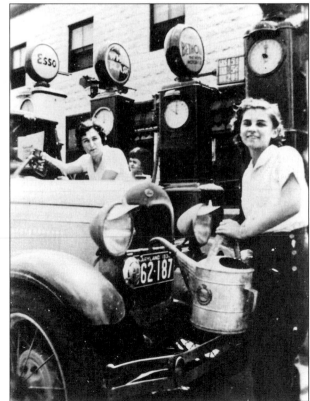

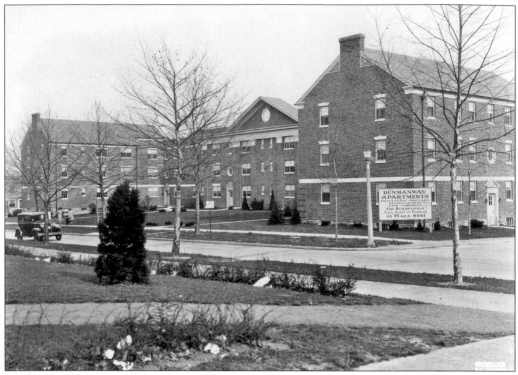

The Dunmanway Apartments look very much the same today as they did when this shot was taken in the 1930s. The sign advertises rent from $30 to $63 per month. (Courtesy Dundalk–Patapsco Neck Historical Society Museum.)

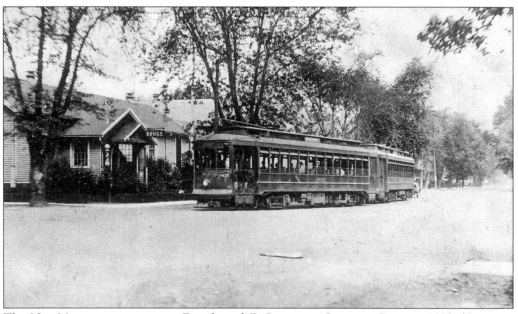

The No. 26 streetcar pauses at Fourth and D Streets in Sparrows Point c. 1935. (Courtesy Dundalk–Patapsco Neck Historical Society Museum.)

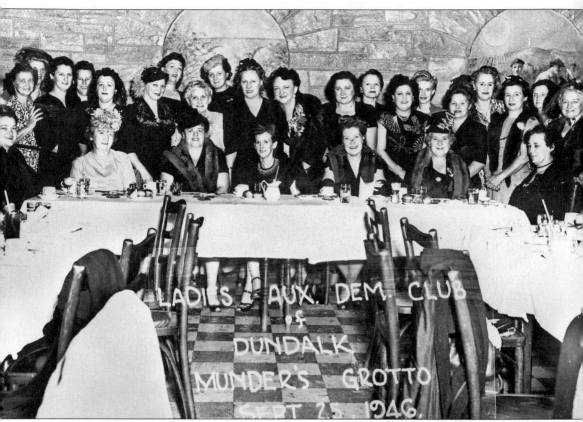

The Ladies Auxiliary Democratic Club of Dundalk featured, from left to right, (first row) Anastasia Turner, Gertrude Money, Barbara Logan, Grace Dorbit, Minnie Harrison, Lucy Cowley, and Mrs. Krouse; (second row) Gladys Belcastro, Ellen Vitek, May Weinholt, Ann Kafer, Doris German, Loretta Flashell, Elizabeth Bossee, Anna Seisman, Catherine Woodhead, Cecilia Vogel, Grace Phillips, Marie Boley, Helen Allen, Kay Earlbeck, Roxie Manley, Cecilia Darby, Ina Segeltore, and Rosie Weiland. The photograph is from 1946. (Courtesy Dundalk–Patapsco Neck Historical Society Museum.)

This long shot shows Woodley Avenue around 1940. Dundalk Elementary can be seen at a distance. (Courtesy Dundalk–Patapsco Neck Historical Society Museum.)

Dr. Joseph Thomas (1885–1963) was one the region's most beloved and respected men. He maintained a medical practice in Turner Station but was also a successful businessman. His enterprises included the Anthony Theatre and Edgewater Beach. Dr. Thomas also owned and frequently traveled with the Baltimore Grays, a Negro League baseball team. He attended St. Rita's Church on Dunmanway and, in 1956, was named Haitian consul for Baltimore by then-president Dwight Eisenhower. (Courtesy Dundalk–Patapsco Neck Historical Society Museum.)

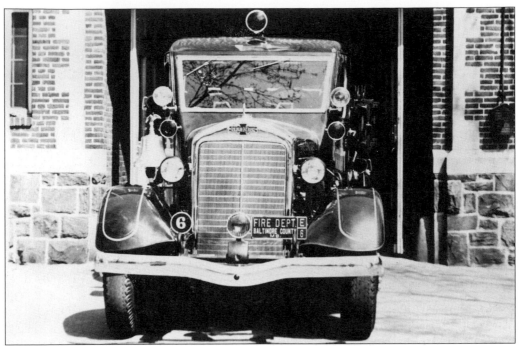

Engine No. 6, a 1937 American LaFrance, could carry 300 gallons of water. It was used by Dundalk firefighters for more than 15 years. The fire department was stationed on Shipping Place from 1920 to 1948. The police department used the Shipping Place address until 1985, when North Point Junior High School was closed and converted into a government center. (Courtesy Dundalk–Patapsco Neck Historical Society Museum.)

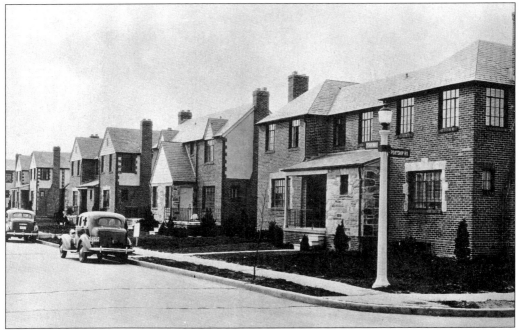

The beautiful homes on Yorkway are seen in this 1930s shot, taken at the intersection of Portship Road. (Courtesy Dundalk–Patapsco Neck Historical Society Museum.)

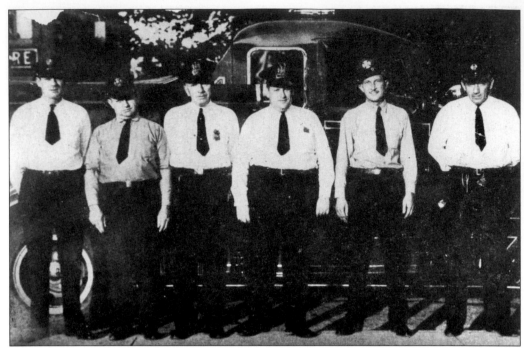

Dundalk police and firemen posed for this photograph, believed to be from the 1940s. The men are, from left to right, Lt. Joseph Kelly, Ed Lynch, Sgt. Harry Baker, officer Arthur Zulauf, Joe Smith, and Capt. Ed Gale. (Courtesy Dundalk–Patapsco Neck Historical Society Museum.)

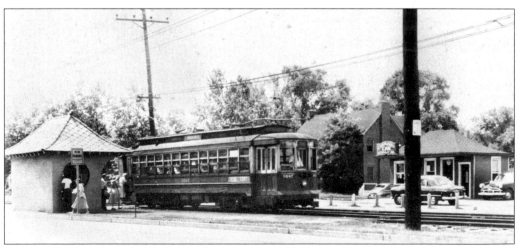

A sign on the side of the No. 26 streetcar at Dundalk Station instructs passengers to board at the rear of the car. Ted Graff's Community Club can be seen in the background of this shot of a summer day in the early 1950s. (Courtesy Dundalk–Patapsco Neck Historical Society Museum.)

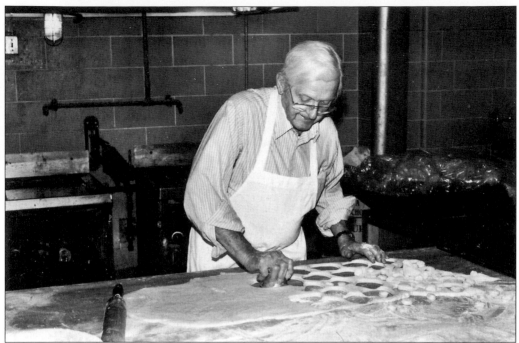

Harry Herman's original bakery, Harry's, was on Fleet Street in Highlandtown. When he expanded, he opened a number of shops in the suburbs, including Dundalk. He was photographed on his 80th birthday working at his Herman's Bakery on Holabird Avenue. (Courtesy Dundalk–Patapsco Neck Historical Society Museum.)

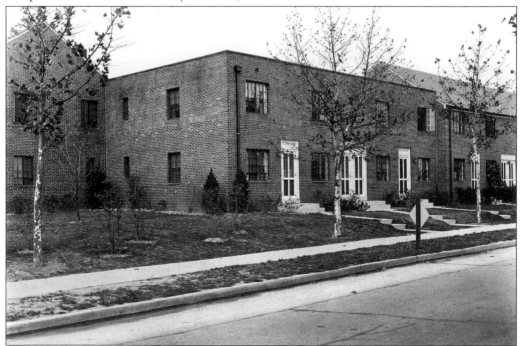

The boxy, red-brick Liberty Park Apartments are shown in this shot from October 15, 1941. (Courtesy Dundalk–Patapsco Neck Historical Society Museum.)

Not all row houses look alike, as seen by these uniquely designed homes on Shipway. One of the characteristics the Dundalk Company built into "Old Dundalk" was the varying styles of architecture. (Courtesy Dundalk–Patapsco Neck Historical Society Museum.)

Dennis Paul "Doc" Lillich founded Lillich's Pharmacy in Dundalk Village in the 1920s. After his death in 1938, his wife, Anne, and pharmacist Calvin Hunter took over the operation. (Courtesy Dundalk–Patapsco Neck Historical Society Museum.)

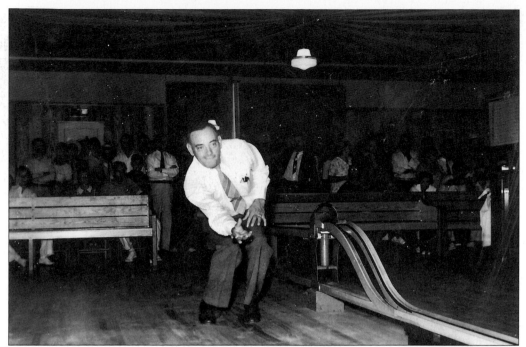

George R. Norris (1891–1960) maintained both his home and business (Norris Ford) in Dundalk. An avid sportsman, he enjoyed duckpins and horse racing and was active in Republican politics. (Courtesy Dundalk–Patapsco Neck Historical Society Museum.)

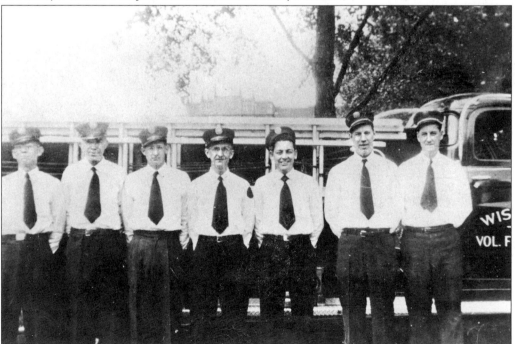

Members of the Wise Avenue Volunteer Fire Department in this picture, from left to right, are Wallace Parrent, Bill Atwell, John Gentile, Lou Huth, unidentified, Alex Mayesk, and unidentified. (Courtesy Dundalk–Patapsco Neck Historical Society Museum.)

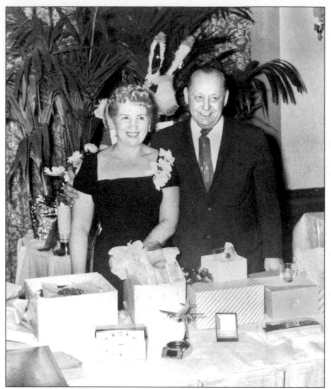

Juanita and Theodore Graff, shown here in the 1960s, may have been the busiest couple in Dundalk during the mid-20th century. They owned and operated multiple businesses, including the Nancy Jeen shop, Community Cab, and Airport Limousine Service. But Ted Graff may be best remembered for founding the Dundalk Bus Line, referred to by locals as "The Blue Bus." Graff's buses operated until 1972 when the state Mass Transit Administration took over the route. In 1938, he hired a nurse for Dundalk Elementary School, paying her from his own payroll for two years before the county assumed the responsibility. Ted Graff was 73 when he died in 1980. Juanita Zang Graff passed away in March 1995. (Courtesy Dundalk–Patapsco Neck Historical Society Museum.)

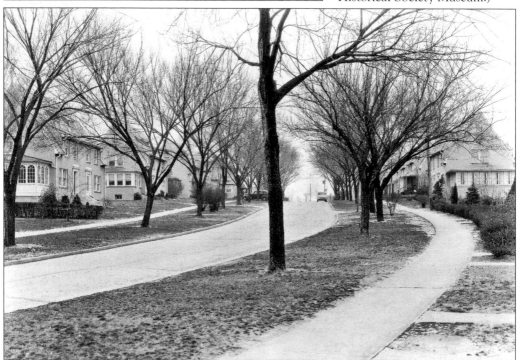

Admiral Boulevard looks practically deserted in this shot from the 1940s. (Courtesy Dundalk–Patapsco Neck Historical Society Museum.)

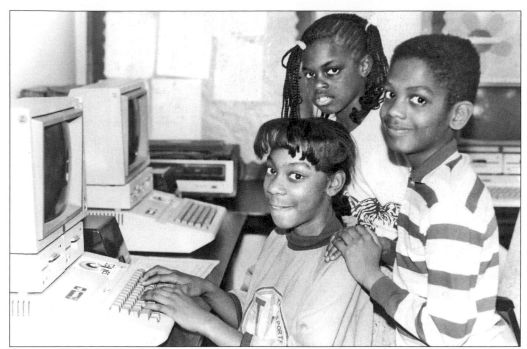

These Turner Station youngsters were enjoying a computer class when this photograph was snapped on May 11, 1989. (Courtesy Dundalk–Patapsco Neck Historical Society Museum.)

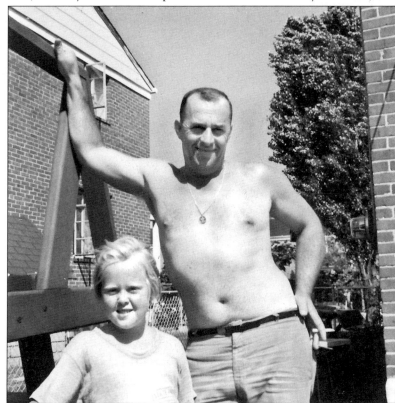

Sparrows Point police officer Frank Zakwieia enjoys some down time with his youngest daughter, Marcee, in the backyard of their Stanbrook home in the mid-1960s. (Courtesy Marcee Zakwieia.)

Esther Wingert Bennett (1909–1998) was a beloved author and educator. A longtime county schoolteacher, she published *Never Prod A Hornet*, about the Battle of North Point, in the late 1960s. The story was later produced as a stage play. Her second book, *The Unseemly Woman*, was published in 1994 when she was 85. The author was privileged to have Bennett for a teacher at Eastwood Elementary in 1964–1965. In addition to the standard fifth-grade curriculum, Bennett taught songs like "Down By The Old Mill Stream" and the old spiritual "Jacob's Ladder." She entertained with outrageous stories that were fondly referred to as "Mrs. Bennett's Tall Tales." A day in Bennett's classroom always began with silent prayer and, if you were fortunate, ended with another star or two next to your name on the classroom star chart. She frequently expressed the hope that one day she would see her students' names in the newspaper "for doing something good." More than 40 years later, Bennett continued to motivate and inspire. She was a genuine treasure. (Courtesy Dundalk–Patapsco Neck Historical Society Museum.)

Joe Czernikowski (1926–2003) was the heart and soul of the Brentwood Inn, which his family owned. Seen here in the 1960s with "Joe's Welcome Wagon," he was a strolling ambassador, entertainer, and mixologist who loved pouring drinks precariously above patrons' heads. His beloved Brentwood went bankrupt and closed in 1982. (Courtesy Dundalk–Patapsco Neck Historical Society Museum.)

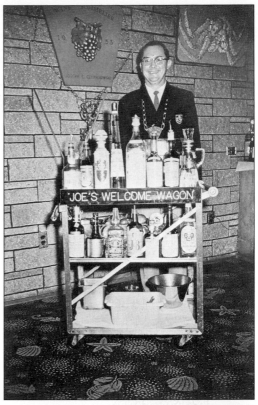

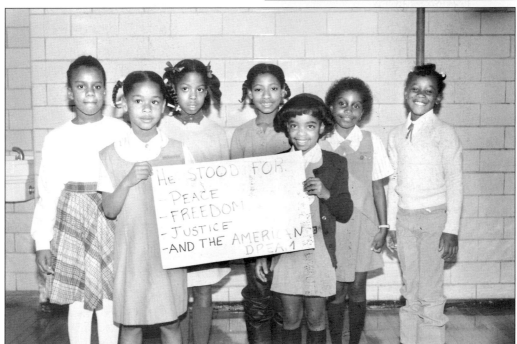

Members of Brownie Troop 1270 of Turner Station are seen here celebrating Martin Luther King Jr. Day on January 23, 1986. (Courtesy Dundalk–Patapsco Neck Historical Society Museum.)

Built by George Hager in the 1920s or 1930s, this uniquely styled residence, called "The Boat House" by locals, has attracted the attention of passing motorists near Fort Howard for years. (Courtesy Dundalk–Patapsco Neck Historical Society Museum.)

On April 11, 1991, kids in Turner Station participated in a community-wide beautification program that included the planting of new seedlings. (Courtesy Dundalk–Patapsco Neck Historical Society Museum.)

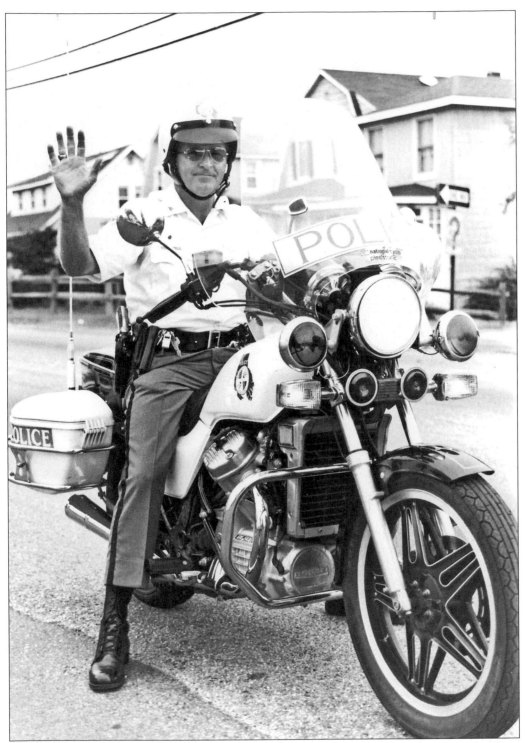

A familiar face in Old Dundalk for years was Baltimore County police officer Fred Shifflett, now retired, who stopped long enough on this day to offer a wave. (Courtesy Dundalk–Patapsco Neck Historical Society Museum.)






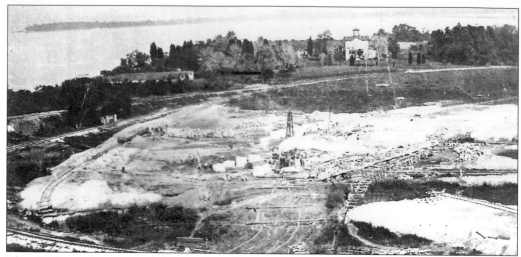

This 1887 aerial view, possibly from a hot-air balloon, shows the former property of Capt. and Mrs. William Fitzell on Sparrows Point as construction of blast furnaces by Pennsylvania Steel is getting underway. It is for all intents and purposes the birth of Dundalk. The Fitzell house can still be seen in the background. Captain Fitzell enjoyed watching boats sail and steam up and down the bay from a vantage point in his rooftop tower. (Courtesy Dundalk–Patapsco Neck Historical Society Museum.)

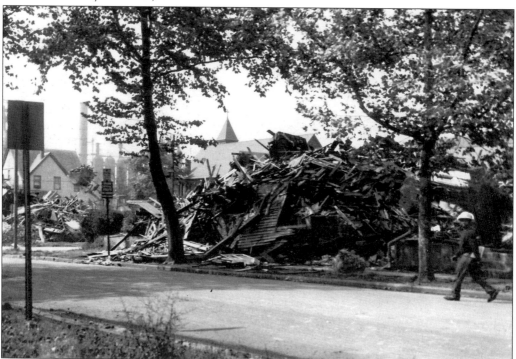

By 1973, Bethlehem Steel had evicted the residents of Sparrows Point and demolished all the commercial and residential buildings to accommodate plant expansion. This 1972 photograph shows what remains of Seventh Street between E and F Streets with the spire of St. Luke's Roman Catholic Church in the background. (Courtesy Dundalk–Patapsco Neck Historical Society Museum.)

Four

THE MILITARY PRESENCE

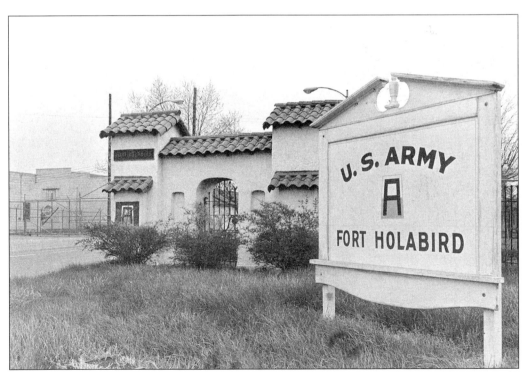

Camp Holabird was established in 1918 on 96 acres of marsh bordering Colgate Creek. Named for Brig. Gen. Samuel Beckley Holabird, a West Point graduate, the camp was initially established as a motor pool and mechanic's school. By the end of 1918, nearly 7,000 men were stationed there. It became Fort Holabird in 1950. (Courtesy Dundalk–Patapsco Neck Historical Society Museum.)

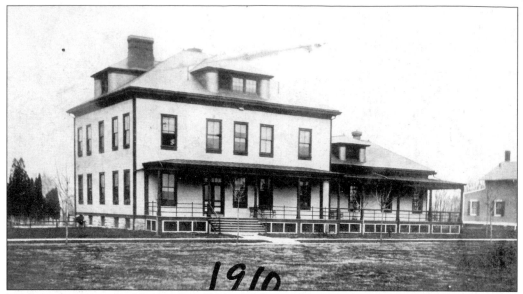

The administration building at Fort Howard is seen in this photograph dated 1910. Established as North Point in 1889, Fort Howard became a military reservation on April 16, 1900, and was named for Revolutionary War colonel and Baltimore philanthropist John Eager Howard. (Courtesy Dundalk–Patapsco Neck Historical Society Museum.)

This shot of an unidentified recruit was snapped at Camp Holabird around 1920. (Courtesy Dundalk–Patapsco Neck Historical Society Museum.)

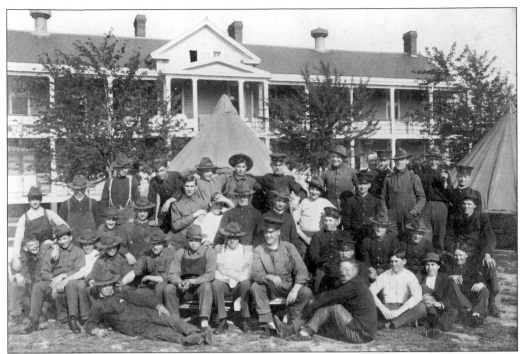

Everyone looks pretty relaxed in this group shot of members of the Coast Artillery Corps, 21st Company, taken at Fort Howard in 1910. (Courtesy Dundalk–Patapsco Neck Historical Society Museum.)

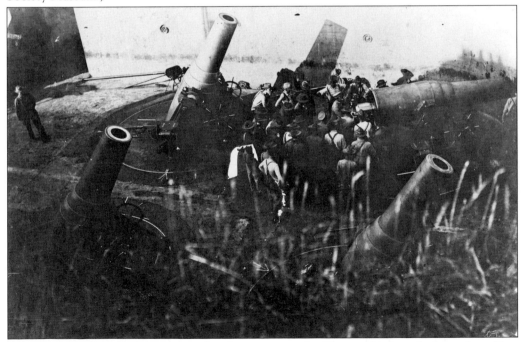

The Coast Artillery Corps is testing their big guns over the Chesapeake from the batteries at Fort Howard in this photograph from 1910. Many of the fort's batteries remain to this day, although the big guns are long gone. (Courtesy Dundalk–Patapsco Neck Historical Society Museum.)

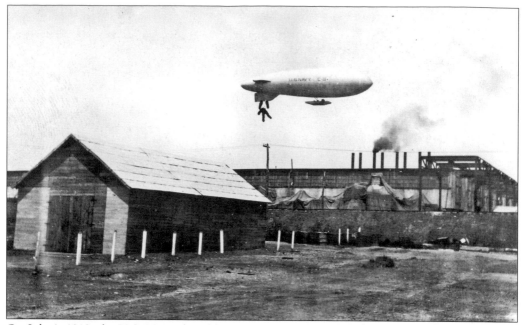

On July 1, 1919, the U.S. Navy dirigible C-8 was photographed over Camp Holabird, en route from Cape May, New Jersey, to Washington, D.C. The blimp had developed rudder problems and detoured to the Dundalk base for repairs. The sight of the ship so low in the air attracted hundreds of spectators, many of them children. (Courtesy Dundalk–Patapsco Neck Historical Society Museum.)

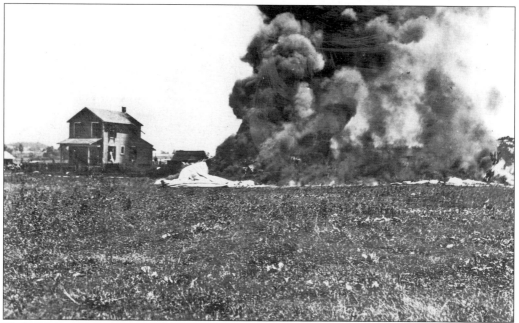

Without warning, the 192-foot dirigible exploded into a ball of fire. This shot was taken less than a minute after the explosion, the concussion of which knocked many spectators to the ground, injuring several. The blimp's six-man crew never had a chance. (Courtesy Dundalk–Patapsco Neck Historical Society Museum.)

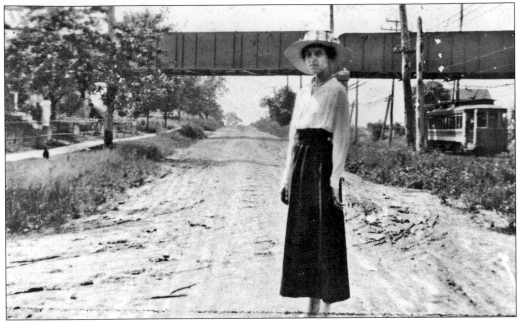

This unidentified woman, reportedly the wife of a Camp Holabird officer, was photographed on Dundalk Avenue, then a dirt road, in 1918 near the railroad overpass leading into the base. The No. 10 streetcar can be seen passing behind her to the right. (Courtesy Dundalk–Patapsco Neck Historical Society Museum.)

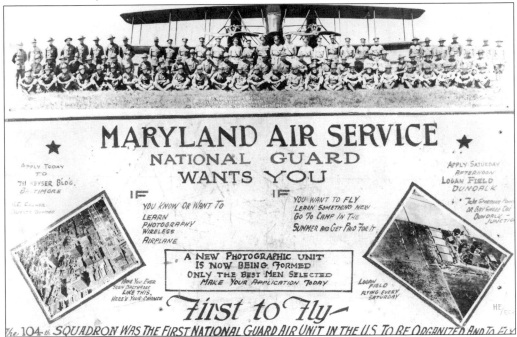

Here is a rare and interesting recruiting advertisement from the early 1920s for the Maryland Air Service National Guard proudly stating that the 104th Squadron was the first in the nation to fly. The 104th was based at Dundalk's Logan Field. (Courtesy Dundalk–Patapsco Neck Historical Society Museum.)

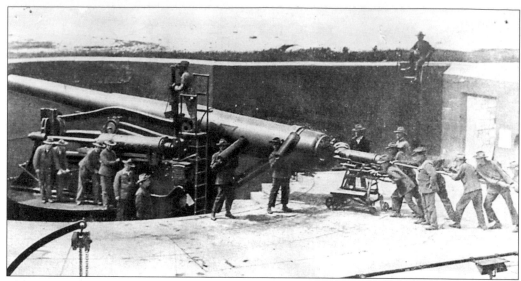

This awesome shot of the Coast Artillery Corps was taken in 1910. It illustrates the precision and teamwork that were necessary to load, aim, and fire the huge guns positioned on the batteries at Fort Howard. (Courtesy Dundalk–Patapsco Neck Historical Society Museum.)

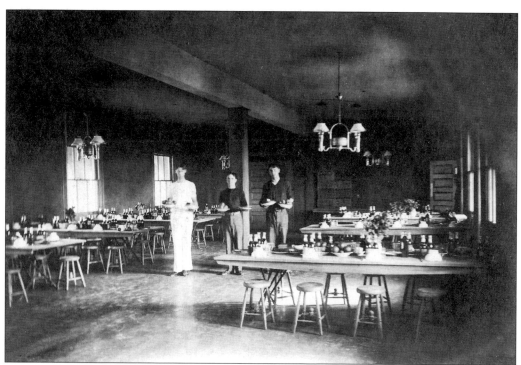

Three American soldiers celebrate a lonely Thanksgiving dinner at Fort Howard on November 24, 1910. (Courtesy Dundalk–Patapsco Neck Historical Society Museum.)

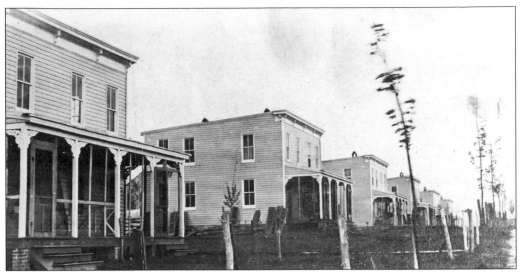

These duplex dwellings at Fort Howard were photographed in 1910. (Courtesy Dundalk–Patapsco Neck Historical Society Museum.)

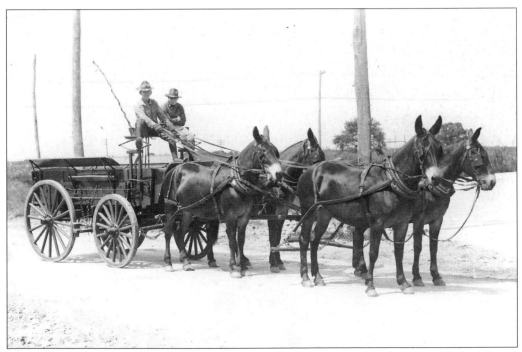

Not everything at Camp Holabird was motorized, as evidenced by this wagon being drawn by a quartet of army mules around 1920. (Courtesy Dundalk–Patapsco Neck Historical Society Museum.)

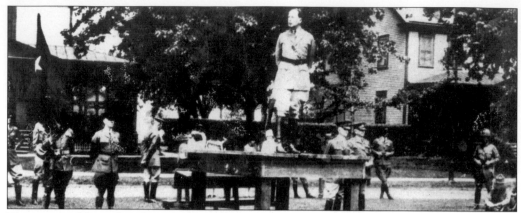

The image is blurry, but the speaker is Gen. Douglas MacArthur, seen here addressing members of the Coast Artillery Corps at Fort Howard in the 1920s. (Courtesy Dundalk–Patapsco Neck Historical Society Museum.)

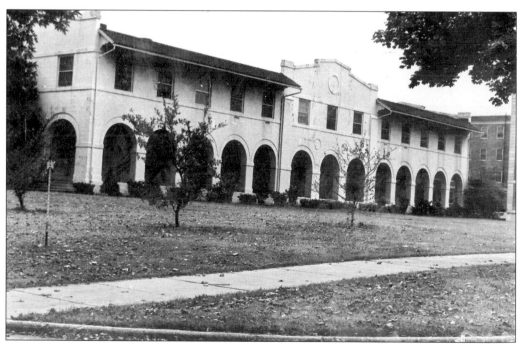

In 1941, the Veteran's Administration acquired Fort Howard from the army. With the opening of the Fort Howard VA Hospital, the barracks shown here became a nurses' residence. (Courtesy Dundalk–Patapsco Neck Historical Society Museum.)

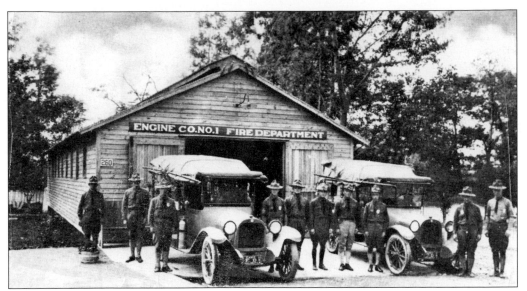

Members of the Camp Holabird Fire Department, Engine Company No. 1, stand ready for action in this photograph from around 1920. (Courtesy Dundalk–Patapsco Neck Historical Society Museum.)

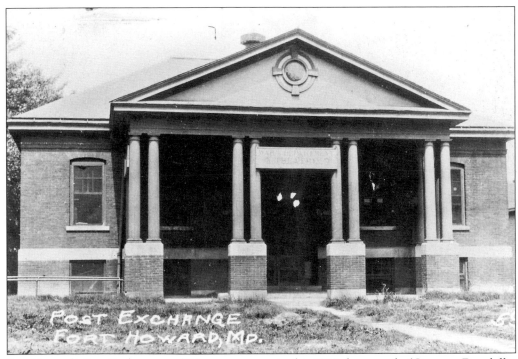

Fort Howard's Post Exchange and Theater are seen in this 1910 photograph. (Courtesy Dundalk–Patapsco Neck Historical Society Museum.)

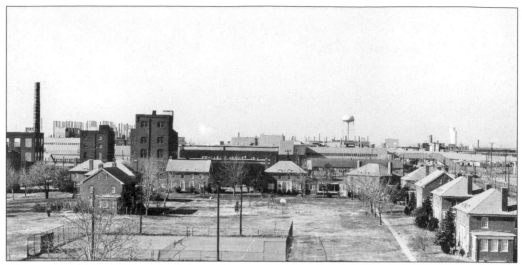

The massive General Motors plant can be seen behind officer's homes at Fort Holabird in this shot from the 1960s or 1970s. (Courtesy Dundalk–Patapsco Neck Historical Society Museum.)

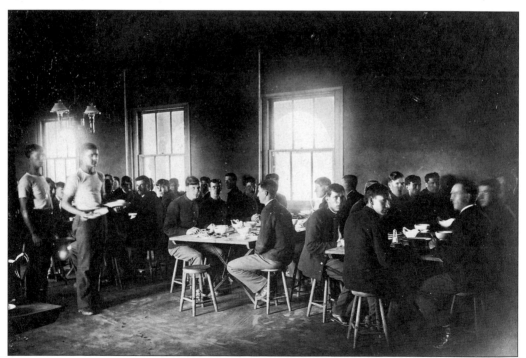

Sunlight filtering in through windows casts an eerie backlight in this photograph of members of the Coast Artillery Corps at Fort Howard enjoying a Sunday dinner in 1910. (Courtesy Dundalk–Patapsco Neck Historical Society Museum.)

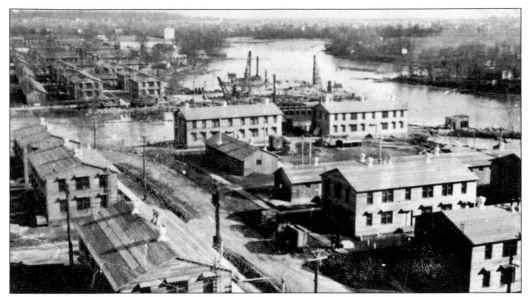

This 1920s aerial view of Camp Holabird shows rows of barracks and Colgate Creek in the background. During World War II, the army's Counter-Intelligence Corps School was established at Camp Holabird. The base was also used to house German prisoners of war. (German POWs were also held at Logan Field.) In the 1970s, Watergate-figure John Dean, convicted of obstruction of justice, served his sentence at Fort Holabird, in a "safe house" facility normally used to hold and protect witnesses against organized crime figures. Following the American pullout in Vietnam, the army closed Fort Holabird and sold the property to the City of Baltimore, which constructed the industrial park that continues to operate there today. (Courtesy Dundalk–Patapsco Neck Historical Society Museum.)

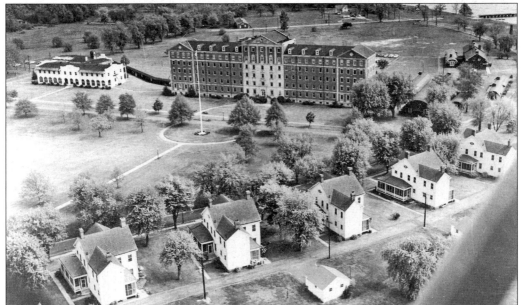

This undated aerial view of Fort Howard shows the VA hospital, which opened in 1941. Years later, during the Vietnam War, Green Beret training took place on the grounds. (Courtesy Dundalk–Patapsco Neck Historical Society Museum.)

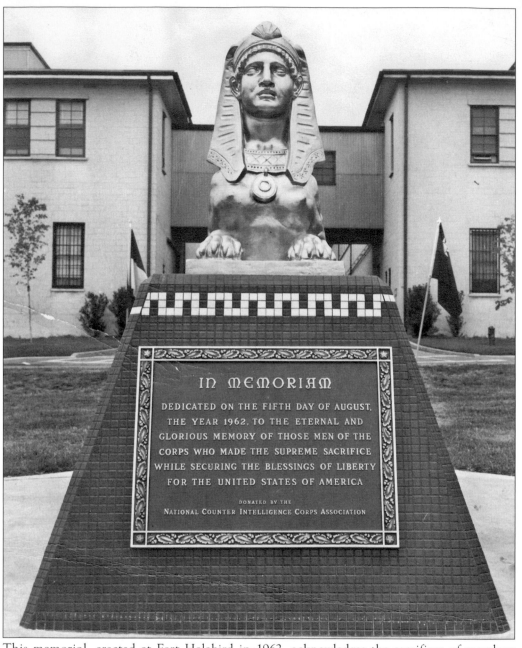

IN MEMORIAM

DEDICATED ON THE FIFTH DAY OF AUGUST,
THE YEAR 1962, TO THE ETERNAL AND
GLORIOUS MEMORY OF THOSE MEN OF THE
CORPS WHO MADE THE SUPREME SACRIFICE
WHILE SECURING THE BLESSINGS OF LIBERTY
FOR THE UNITED STATES OF AMERICA

DONATED BY THE
NATIONAL COUNTER INTELLIGENCE CORPS ASSOCIATION

This memorial, erected at Fort Holabird in 1962, acknowledges the sacrifices of members of the army's Counter-Intelligence Corps. (Courtesy Dundalk–Patapsco Neck Historical Society Museum.)

Five

SCHOOLS

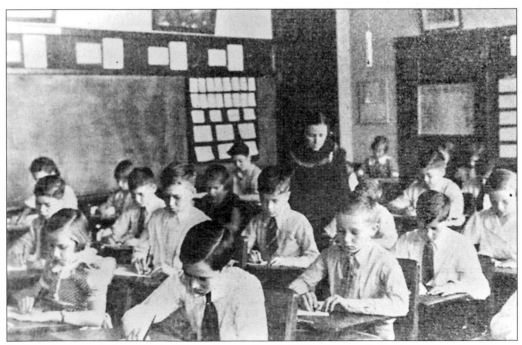

In this photograph from 1934, fifth graders at Dundalk Elementary School appear to be taking a test under the watchful eye of their teacher. (Courtesy Baltimore County Public Library.)

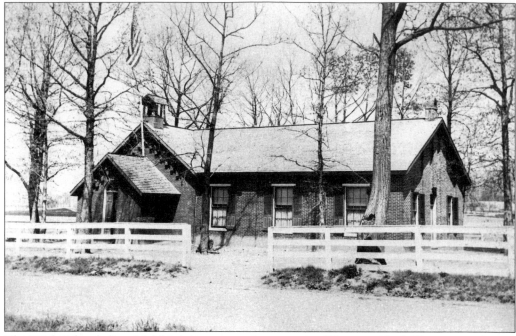

The Brick School #3 on Holabird Avenue was later renamed Patapsco Neck Elementary. A one-room schoolhouse, it accommodated grades one through five. One source says the school was built in 1877, another says 1899. In either case, it was used until 1938, when a new school was constructed across the street. This photograph is from the 1920s or 1930s. The building remains in use today as a pub. (Courtesy Baltimore County Public Library.)

Dundalk Elementary first graders, in costume for a school activity, posed for this group picture on June 12, 1930. (Courtesy Dundalk–Patapsco Neck Historical Society Museum.)

Members of the Dundalk Junior High basketball team posed for this team photograph in 1939. (Courtesy Baltimore County Public Library.)

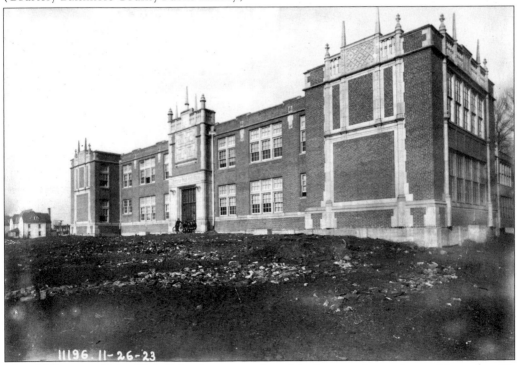

The old Sparrows Point High School was new when this photograph was shot on November 26, 1923. (Courtesy Dundalk–Patapsco Neck Historical Society Museum.)

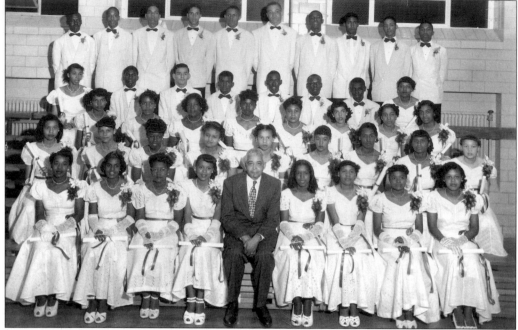

The first graduating class of Sollers Point High is seen here with school principal Charles Fletcher in 1949. Like much of the country, Dundalk's neighborhoods and schools were divided by racial lines through the first two-thirds of the 20th century. Sollers Point served African American youngsters from the Turner Station community. (Courtesy Dr. Theodore Patterson.)

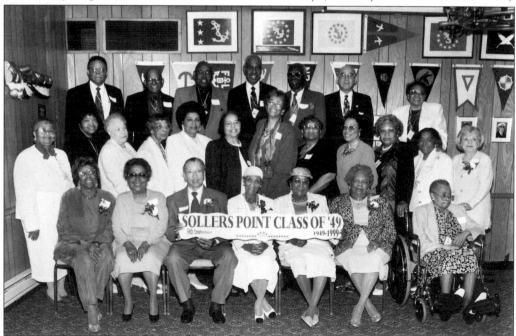

Fifty years later, surviving members of Sollers Point's class of 1949, along with members of the faculty, were reunited for this photograph, taken April 25, 1999. Dr. Ted Patterson can be seen in the back row, second from the right. (Courtesy Dr. Theodore Patterson.)

Members of the Fort Holabird Color Guard did the honors as the first flag-raising ceremony took place at the new Grange Elementary School on October 28, 1960. About 75 parents joined students and teachers for the morning activities. Alfred G. Sultzer was the school's first principal. (Courtesy Marcee Zakwieia.)

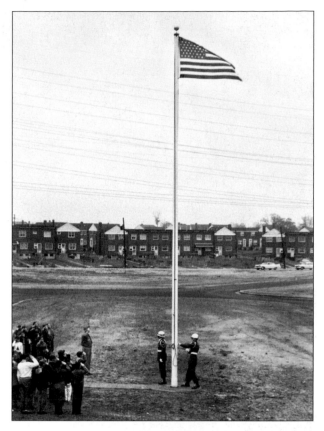

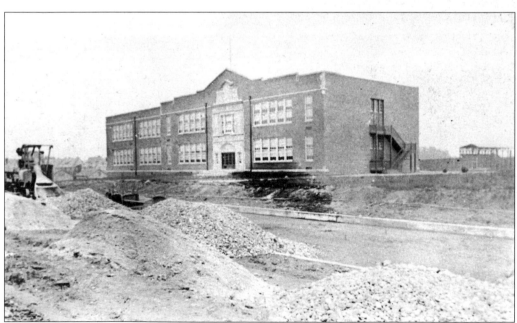

Playfield Street was still under construction when this photograph of the new Dundalk Elementary School was snapped in 1926. (Courtesy Dundalk–Patapsco Neck Historical Society Museum.)

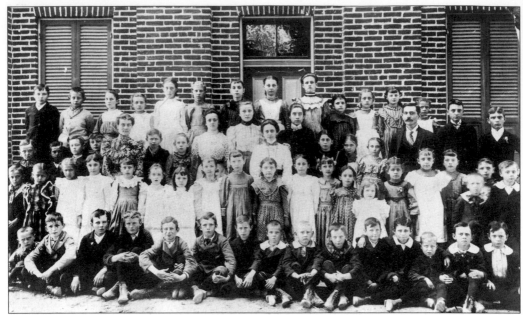

Patapsco Neck Elementary students pose beside the Holabird Avenue school in 1900. (Courtesy Dundalk–Patapsco Neck Historical Society Museum.)

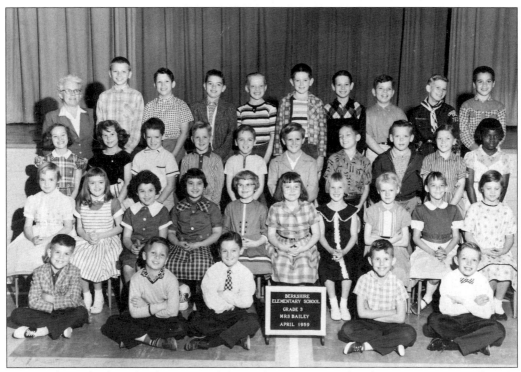

Mrs. Bailey's third-grade class at Berkshire Elementary sat for this picture in April 1959. (Courtesy Dundalk–Patapsco Neck Historical Society Museum.)

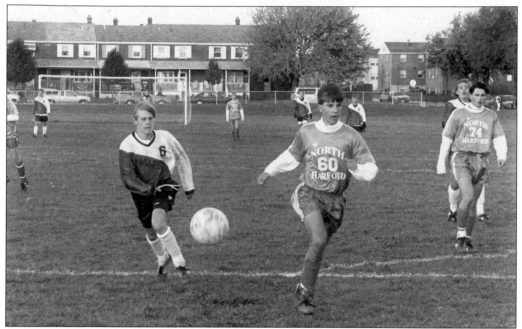

Patapsco's No. 6, Chuck Little, pursues the ball in this November 16, 1995, matchup against North Harford High. The Patriots' reputation as a dominant force in high school soccer dates back to the days when the late Rich Bartos coached Patapsco's soccer teams in the 1970s. (Courtesy Dundalk–Patapsco Neck Historical Society Museum.)

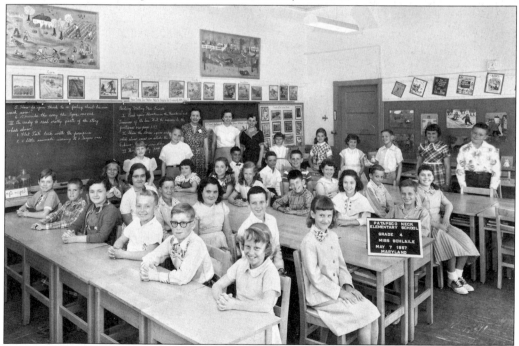

Another class picture, this time of Miss Schlaile's fourth graders at Patapsco Neck Elementary, was taken May 7, 1957. Patapsco Neck closed in the 1980s, but the Holabird Avenue building remains open as a county senior center. (Courtesy Dundalk–Patapsco Neck Historical Society Museum.)

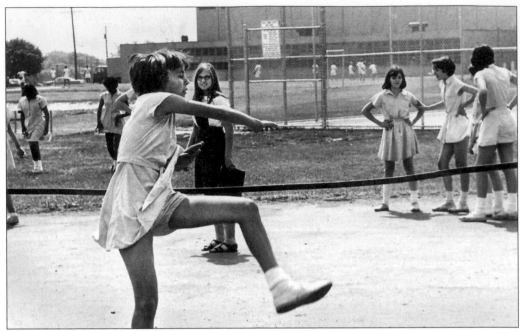

It's 1966, and Mary Ellen Zakwieia participates in the high jump in gym class at Dundalk Junior High School. (Courtesy Marcee Zakwieia.)

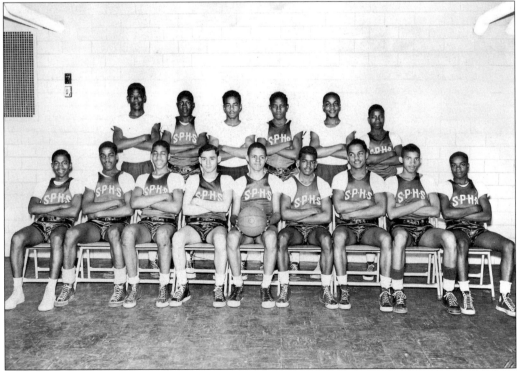

Here is Sollers Point High School's first basketball team, from the 1948–1949 school year. Dr. Ted Patterson is seated in the first row, fourth from the left. J. Bruce Turner was the team's coach. (Courtesy Dr. Theodore Patterson.)

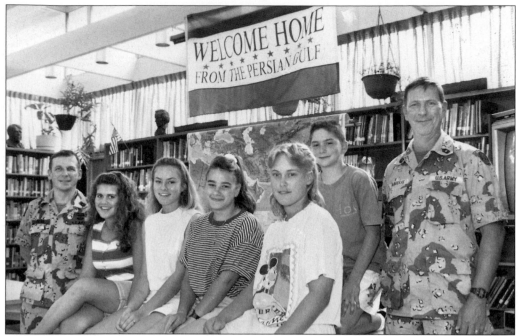

Students from Patapsco High School, seated from left to right, Jill Blimline, Kirsten Ruke, Nicole Travagline, Teresa Wrzosek, and Mike Wilson, welcome U.S. Army Master Sergeants Earle (left) and Navickas (right) home from the Persian Gulf in the early 1990s. (Courtesy Dundalk–Patapsco Neck Historical Society Museum.)

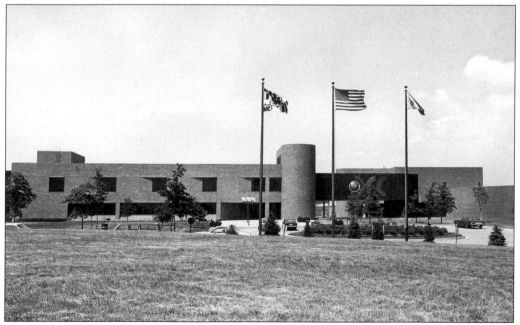

After a long process that began back in 1962, ground was broken for Dundalk Community College on October 12, 1971. Over the years, it has expanded both physically and in terms of academic offerings and is now referred to as the Community College of Baltimore County (CCBC), Dundalk Campus. (Courtesy Dundalk–Patapsco Neck Historical Society Museum.)

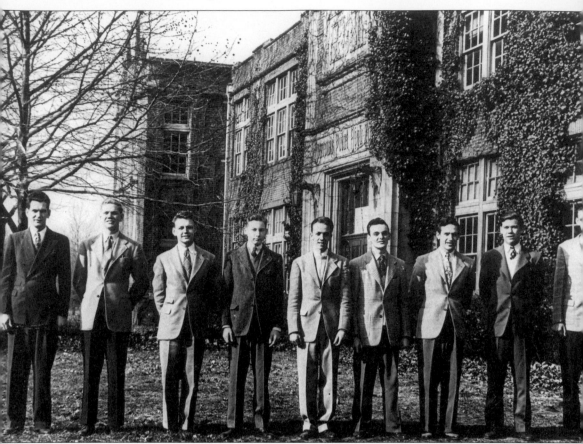

In 1944, Baltimore County gave special permission for nine male students at Sparrows Point High to graduate in January rather than June so that they could enlist in the armed forces. All had to put in extra time, doubling up on English, history, and algebra classes. From left to right, the young men are William Wortman, John Wellinger, David Welhelm, Bill Strickler, Robert Newsom, James Dolan, Carl Tippett, Allen Clinedinst, and Joseph Pika. Wortman joined the army. Wellinger enlisted in the Marines. Tippett went into the Navy Air Corps. They each returned after serving their country. David Welhelm also joined the army but lost his life during the D-Day invasion of France less than five months after this photograph was taken. No information could be found on the remaining five. (Courtesy Dundalk–Patapsco Neck Historical Society Museum.)

Six

CHURCHES

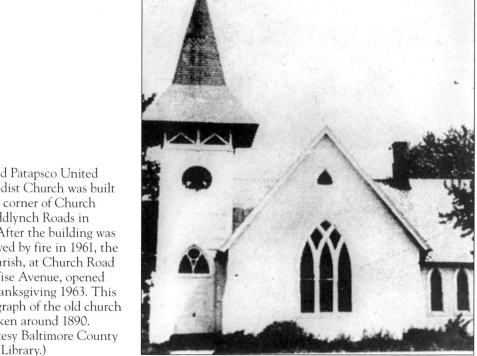

The old Patapsco United Methodist Church was built on the corner of Church and Eddlynch Roads in 1887. After the building was destroyed by fire in 1961, the new parish, at Church Road and Wise Avenue, opened on Thanksgiving 1963. This photograph of the old church was taken around 1890. (Courtesy Baltimore County Public Library.)

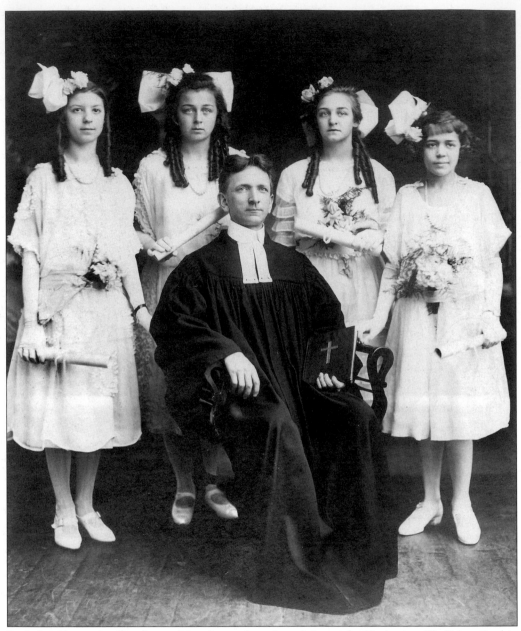

St. Luke's Evangelical Lutheran Church members, from left to right, Katherine Gladfelter, Sophie Stratmann, Marie Stratmann, and Alfredia Wolf posed with Pastor C. F. William Harltage for this 1923 photograph. (Courtesy Dundalk–Patapsco Neck Historical Society Museum.)

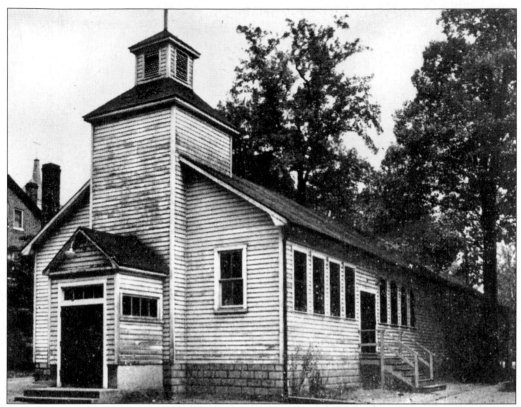

St. Rita's Roman Catholic Church on Dunmanway in 1922 is shown here. The building was actually a surplus World War I barrack from Camp Holabird purchased for $2,000 and erected by the men of the church. (Courtesy Dundalk–Patapsco Neck Historical Society Museum.)

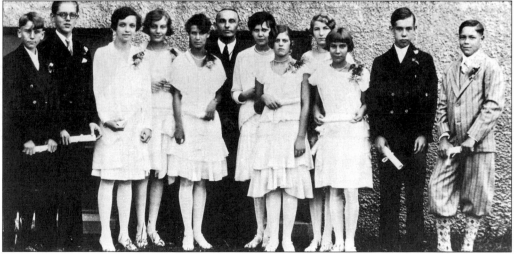

Members of the first confirmation class of St. Timothy's Lutheran Church (in 1929) were, from left to right, William Beer, Oscar Suttka, Ruth McDonough, Margaret Norris, Della Waliniemi, Lorraine Diekmann, Aino Raukko, Lenora Klemm, Laila Waliniemi, John Marshall, and Blaine Deem. With the confirmands in the center is Pastor Walter Mertz. (Courtesy Dundalk–Patapsco Neck Historical Society Museum.)

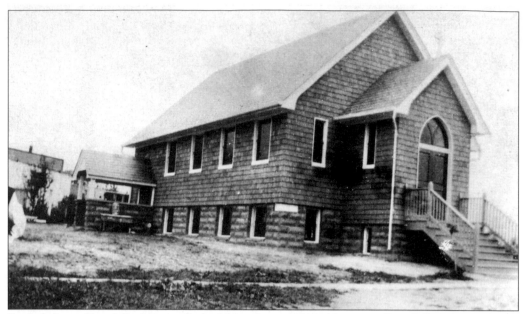

St. Luke's on Dundalk Avenue looked like this in 1915. (Courtesy Dundalk–Patapsco Neck Historical Society Museum.)

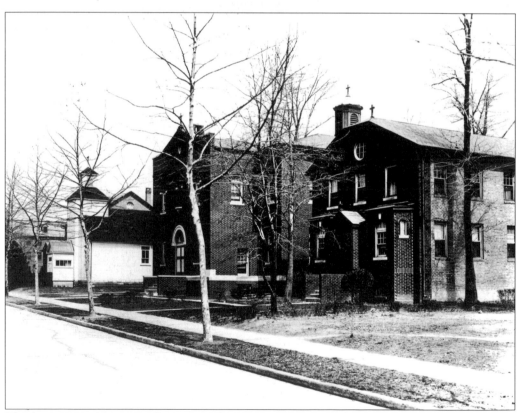

This later view of St. Rita's shows, from left to right, the church, school, and convent. (Courtesy Dundalk–Patapsco Neck Historical Society Museum.)

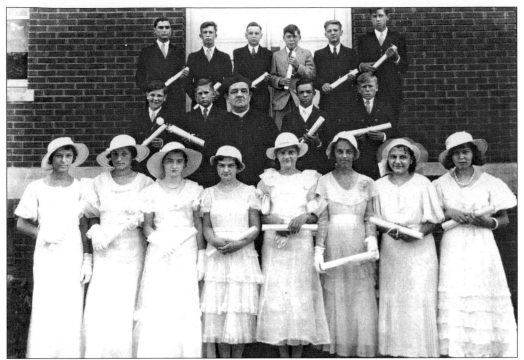

St. Rita's confirmation class of 1933 is shown here. Fr. Joseph Wiedenham can be seen at the center of the group. (Courtesy Dundalk–Patapsco Neck Historical Society Museum.)

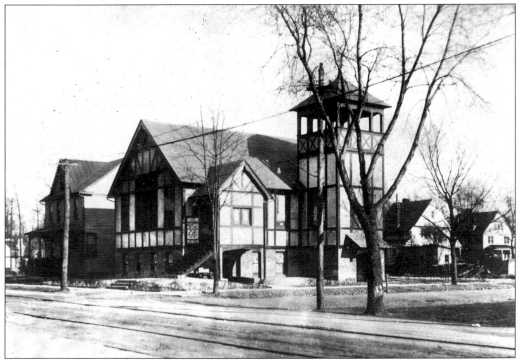

St. John's Evangelical Lutheran Church at Seventh and D Streets in Sparrows Point was built in 1889. (Courtesy Dundalk–Patapsco Neck Historical Society Museum.)

The Thorne House was the first parsonage of the Patapsco United Methodist Church. It is still standing today on Church Road between Trappe Road and Wise Avenue. (Courtesy Baltimore County Public Library.)

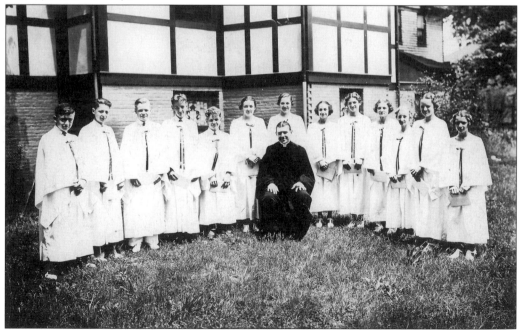

The 1937 confirmation class of St. John's Evangelical Lutheran Church in Sparrows Point is shown here. Marcella Pac (née Miller), now a resident of Oak Crest Village in Parkville, is sixth from the right. (Courtesy Marcee Zakwieia.)

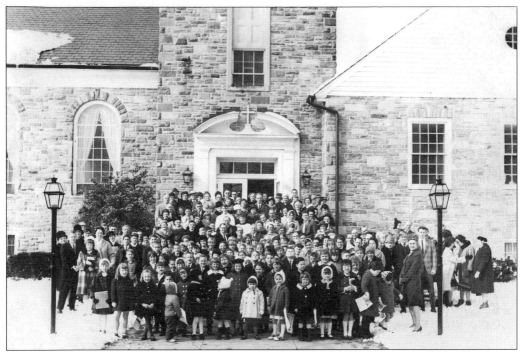

Members of the Dundalk United Methodist Church on Mornington Road gathered for this undated group shot on a snowy Sunday morning. Judging by the fashions, it is probably from the late 1950s or early 1960s. (Courtesy Dundalk–Patapsco Neck Historical Society Museum.)

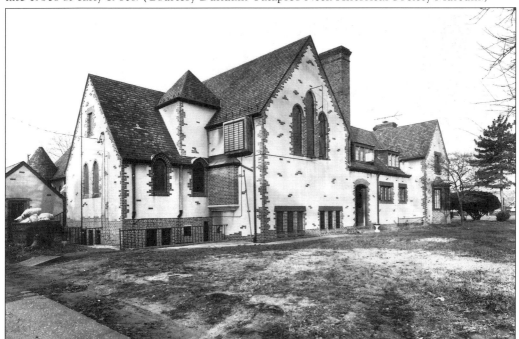

One of Dundalk's most attractive churches is St. George's and St. Matthew Episcopal at Dundalk Avenue and Center Place. Its unique architecture is complemented by beautiful grounds. (Courtesy Dundalk–Patapsco Neck Historical Society Museum.)

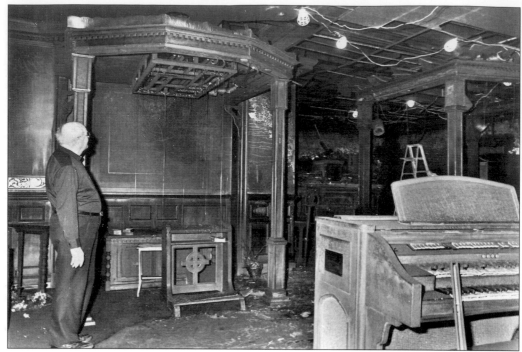

Fr. Richard E. Parks is seen here surveying the damage to Sacred Heart of Mary Roman Catholic Church after a fire caused by unattended candles in March 1995. (Courtesy Dundalk–Patapsco Neck Historical Society Museum.)

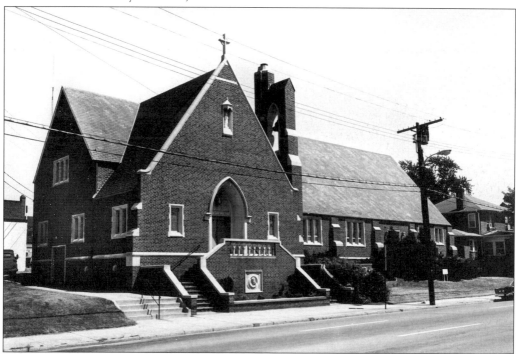

This undated image represents the current look of St. Luke's Lutheran at 1803 Dundalk Avenue. (Courtesy Dundalk–Patapsco Neck Historical Society Museum.)

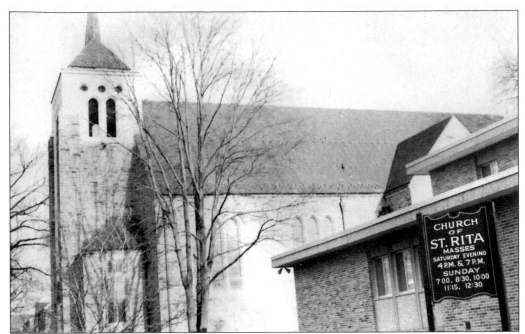

Here is a modern-day view of beautiful St. Rita's on Dunmanway. (Courtesy Dundalk–Patapsco Neck Historical Society Museum.)

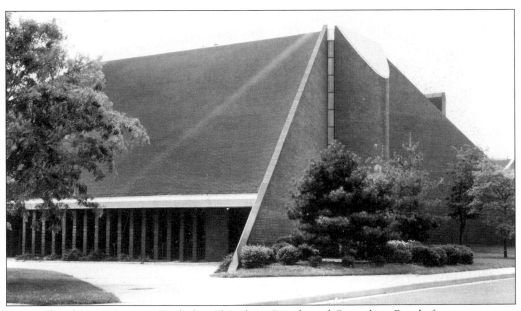

Our Lady of Hope Roman Catholic Church at Lynch and Boundary Roads features a more contemporary-styled parish built in 1970. (Courtesy Dundalk–Patapsco Neck Historical Society Museum.)

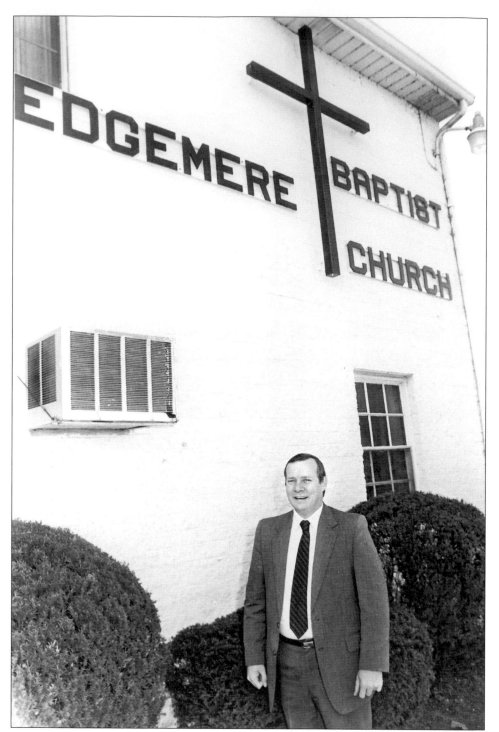

A few years back, the Sunday school students at Edgemere Baptist Church wanted to do their part to help pay for the church's new roof. So they collected a mile of pennies—84,480 to be exact. Pastor Erik Garthe is seen here at the North Point Road church. (Courtesy Dundalk–Patapsco Neck Historical Society Museum.)

Seven

RECREATION

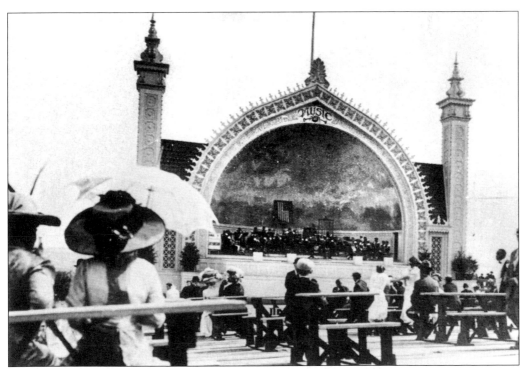

Bay Shore Park, like Riverview Park, was owned and operated by the United Railway and Electric Company. Opening in 1906, it was a popular bathing beach that featured a restaurant, trolley station, dance hall, duckpin bowling center, and this, the Edwardian-styled band shell. United's (and later Baltimore Transit's) streetcars carried thousands of happy Baltimoreans to Bay Shore every summer. (Courtesy Dundalk–Patapsco Neck Historical Society Museum.)

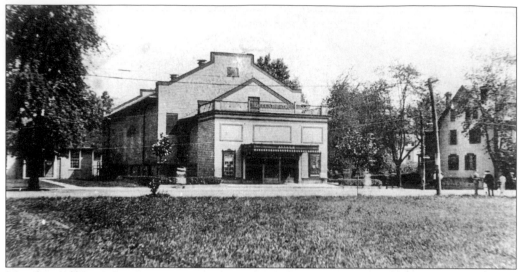

This is probably the earliest photograph of a Dundalk-area movie house. The Lyceum, at Fifth and D Streets in Sparrows Point, is shown here in 1912 shortly after it opened. Yet it wasn't the first theatre in the area. That distinction goes to the Casino, which opened in 1909, also on D Street. During the silent movie days, a volunteer from the community played piano for background music at the Lyceum, which closed in 1947 after part of the roof collapsed under the weight of a heavy rain. (Courtesy Dundalk–Patapsco Neck Historical Society Museum.)

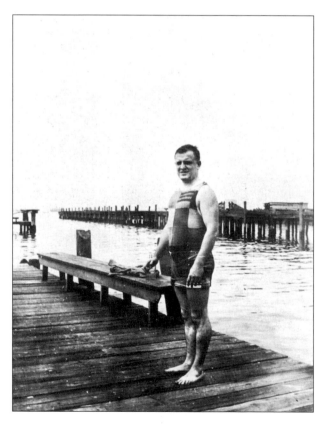

This bather at the Maryland Swimming Club shows off the latest in early-1900s men's swimwear. (Courtesy Dundalk–Patapsco Neck Historical Society Museum.)

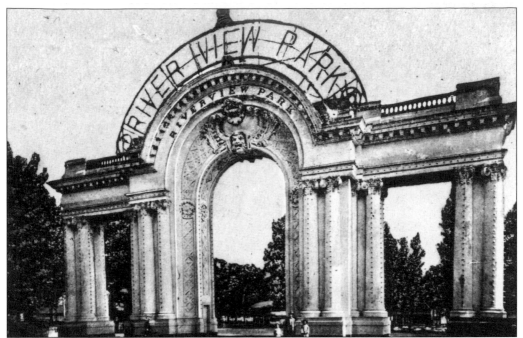

Riverview Park on Colgate Creek sported this elegant entrance in the early 1900s. Its location on Point Breeze usually insured that air would be gently stirring even on the most humid summer days. Visitors came from up and down the Atlantic coast, enjoying the bathing beach, amusements, food, and dance hall. It closed in 1929 after 31 years of operation to make way for Bell Telephone's new Western Electric plant. (Courtesy Dundalk–Patapsco Neck Historical Society Museum.)

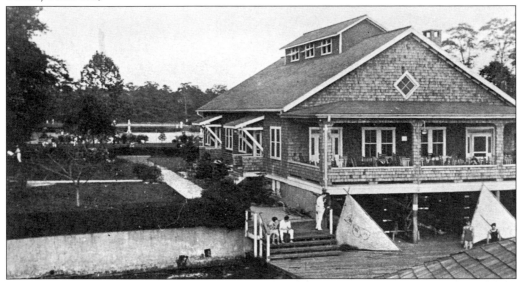

The Maryland Swimming Club was established by William McShane in 1903. Situated near the present location of the Dundalk American Legion Post No. 38, it featured swimming, sailing, baseball, canoeing, soccer, and first-rate clay tennis courts. The club lasted until 1928, when the City of Baltimore purchased the land and filled in several acres of shoreline to construct Harbor Field. (Courtesy Dundalk–Patapsco Neck Historical Society Museum.)

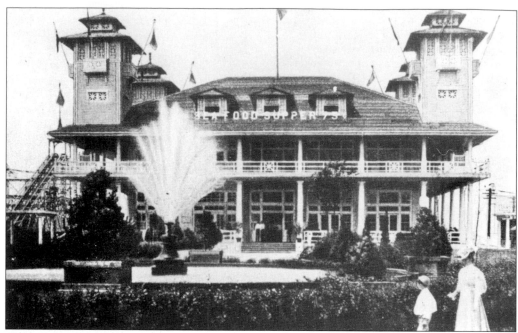

The sign atop the restaurant at Bay Shore Park advertises a "Seafood Supper for 75 Cents." This shot is believed to have been taken around 1910. (Courtesy Dundalk–Patapsco Neck Historical Society Museum.)

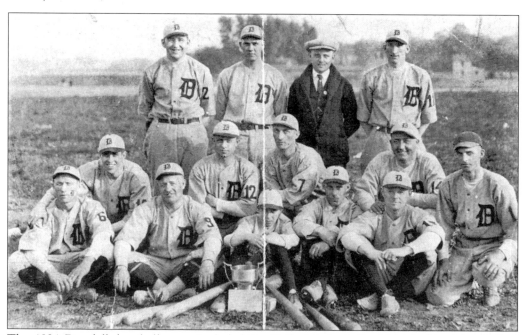

The 1924 Dundalk baseball team included Jim Kelly (pitcher), Fred Unick (third base), Bud Dearis (short stop), Steward Maxwell (pitcher), Lew Smith (pitcher), Scotty Newton (second base), Jerry Jowski (catcher), Joe Atkins (pitcher), Benny Gozetal (outfield), and Elmer Lingstone (third base). Charlie Campbell (third row, second from right) was the owner. (Courtesy Dundalk–Patapsco Neck Historical Society Museum.)

This view of the pier and water was taken from the Maryland Swimming Club in the 1920s. All this was later backfilled to make Harbor Field using dirt from the current site of CCBC's Dundalk Campus. (Courtesy Dundalk–Patapsco Neck Historical Society Museum.)

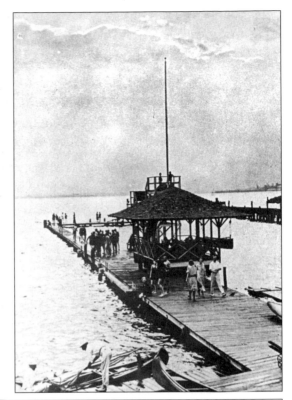

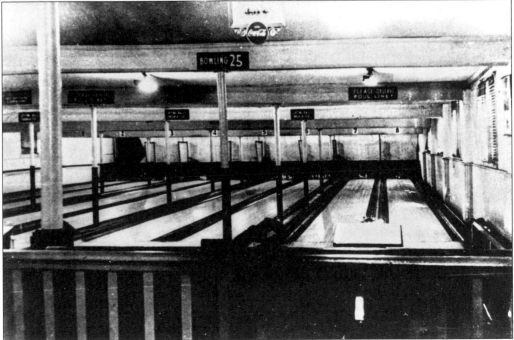

This eight-lane duckpin center was located in the basement of Sparrows Point's Lyceum Theatre. Dundalkians have always been passionate about duckpins. Bowling was a quarter a game back then. (Courtesy Dundalk–Patapsco Neck Historical Society Museum.)

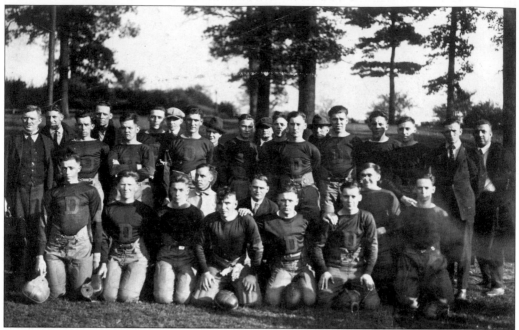

Dundalk's 1921 football team got together for this photograph, shot at Dunmanway and Liberty Parkway. The area in the background became the Dundalk Garden Apartments and Dundalk Junior High School. (Courtesy Dundalk–Patapsco Neck Historical Society Museum.)

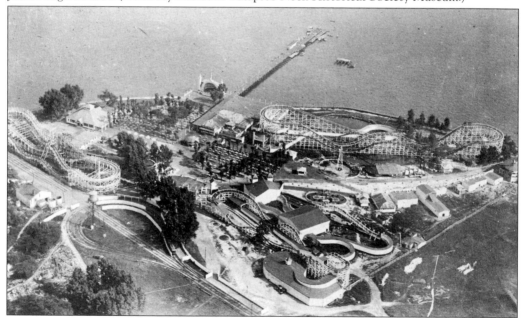

Riverview Park's three wooden roller coasters can be seen in this aerial photo from the 1920s. Also visible at the top of the picture are the pier and a band shell, which looked remarkably like the one at Bay Shore Park. That is no surprise, since the United Railways and Electric Company owned both facilities. Young people today would scoff at the park's size and limited attractions. But by early 20th century standards, it was most impressive, even attracting visitors from out of state. (Courtesy Dundalk–Patapsco Neck Historical Society Museum.)

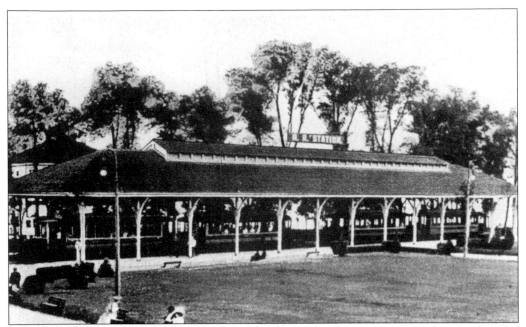

Visitors to Bay Shore Park who traveled by streetcar boarded and disembarked here, at the entrance to the park. After 42 years, Bay Shore Park closed in 1948 when Bethlehem Steel purchased the property for expansion. Ironically, the company never used the land and eventually sold it to the Maryland Department of Natural Resources in 1987. Today it is North Point State Park. This trolley station, recently refurbished, is all that is left of Bay Shore Park. (Courtesy Dundalk–Patapsco Neck Historical Society Museum.)

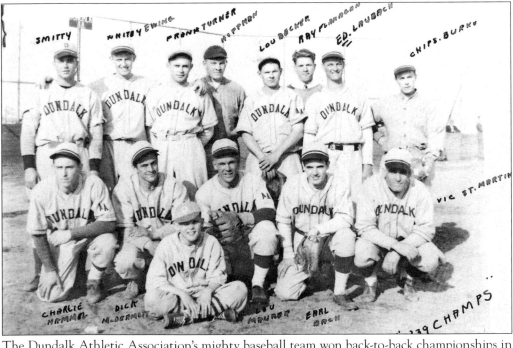

The Dundalk Athletic Association's mighty baseball team won back-to-back championships in 1938 and 1939. (Courtesy Dundalk–Patapsco Neck Historical Society Museum.)

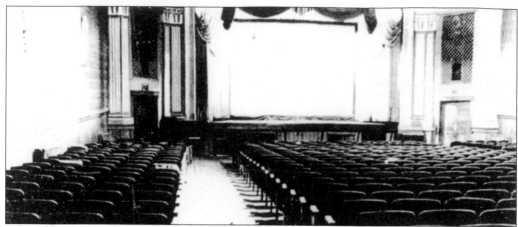

This photograph of the interior of the Lyceum Theatre was taken during the 1940s. From 1912 to 1947, schools and groups frequently rented the theatre for presentations, graduations, and the like. (Courtesy Dundalk–Patapsco Neck Historical Society Museum.)

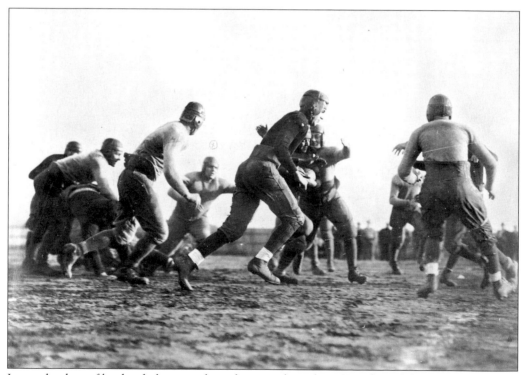

It was the days of leather helmets without face guards in this 1920s shot of the Dundalk football team in action. (Courtesy Dundalk–Patapsco Neck Historical Society Museum.)

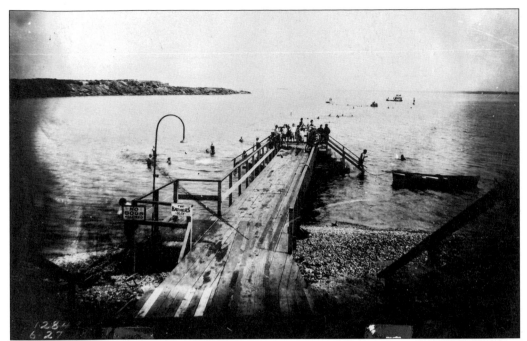

An early-20th-century view of the Sparrows Point Bathing Beach shows the pier, with steps on either side leading down to the water. (Courtesy Dundalk–Patapsco Neck Historical Society Museum.)

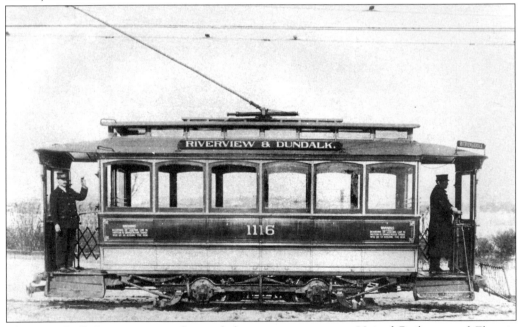

The J. G. Brill Company manufactured this open-air streetcar. United Railways and Electric Company bought 110 of them in 1902 and used them during the summer on the No. 10 line between Roland Park, Highlandtown, and Riverview Park. One of these cars, No. 1164, was salvaged and restored and is on display at the Baltimore Streetcar Museum. (Courtesy Dundalk–Patapsco Neck Historical Society Museum.)

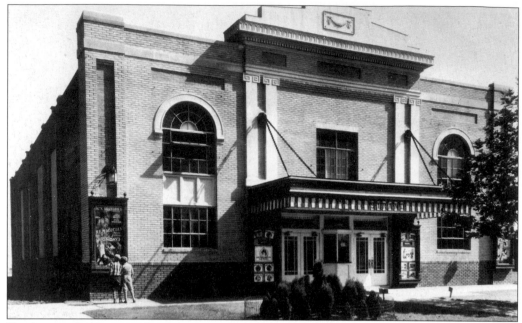

Here's an early photograph of the Strand Theatre, probably taken during the summer of 1927. Before a marquee was constructed in the 1930s, a small roof covered the entranceway, shielding theatergoers from the elements. Note the two young boys at the left, both in knickers, reading a poster advertising the appearance of a magician. (Courtesy Dundalk–Patapsco Neck Historical Society Museum.)

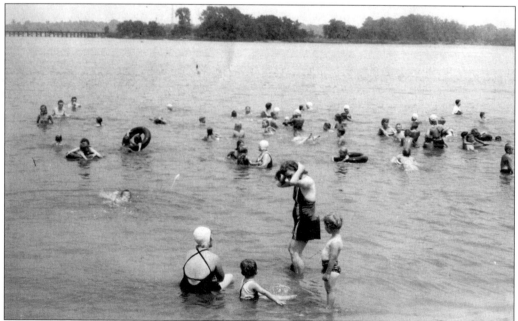

Over the years, it was referred to as the Snake Hole and then the Dundalk Bathing Beach. Eventually it became Merritt Point Park. This image is from the 1930s or 1940s. The park remains open today; however, swimming was banned due to pollution in the mid-1960s. (Courtesy Dundalk–Patapsco Neck Historical Society Museum.)

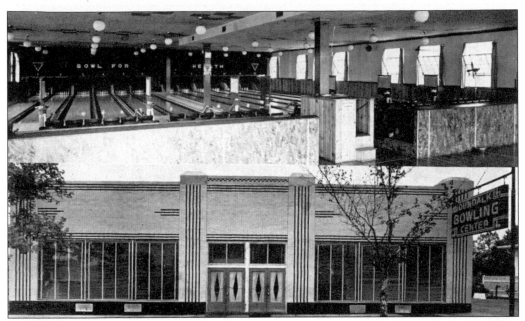

The Dundalk Bowling Center was on Holabird Avenue across from Squire's Restaurant. The building still exists, but its days as a bowling alley are history; it is now a medical office. (Courtesy Dundalk–Patapsco Neck Historical Society Museum.)

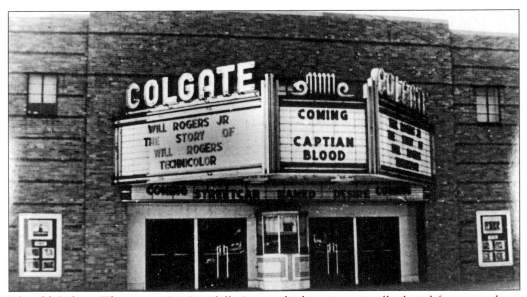

The old Colgate Theatre at 1718 Dundalk Avenue had an exceptionally short lifespan, perhaps because of the advent of television. Now a union hall, the Colgate was around just five years, from 1948 to 1953. (Courtesy Dundalk–Patapsco Neck Historical Society Museum.)

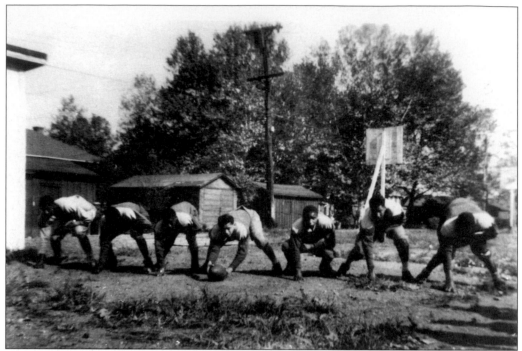

The young man centering the football, Ted Patterson, grew up to be a doctor. This 1940s team, one of many neighborhood football clubs, was called the Sparrows Point Seahawks. (Courtesy Dr. Theodore Patterson.)

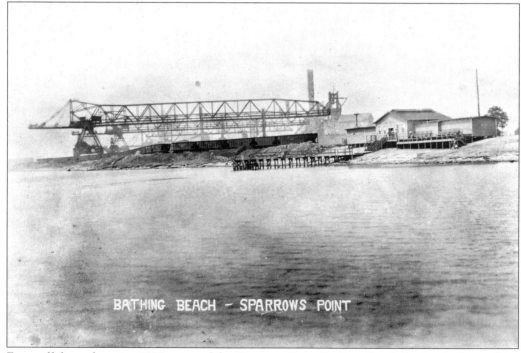

From off shore, here is a 1930s view of the Sparrows Point Bathing Beach in the shadows of the Bethlehem Steel plant. (Courtesy Dundalk–Patapsco Neck Historical Society Museum.)

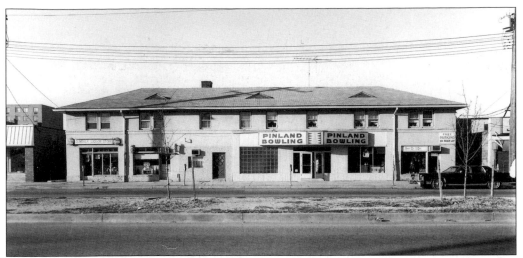

Frank Litrenta established Pinland on Dundalk Avenue in 1951 after Norris Ford moved out of the building. Originating in Baltimore, duckpin bowling has always been a regional sport, with lanes primarily along the East Coast from Massachusetts to North Carolina. The sport's popularity has waned over the last 25 years, but in the summer of 2005, there were still 31 duckpin bowling centers in Maryland. Three are in Dundalk—Pinland, Edgemere Bowl-A-Drome, and AMF Eastpoint. (Courtesy Dundalk–Patapsco Neck Historical Society Museum.)

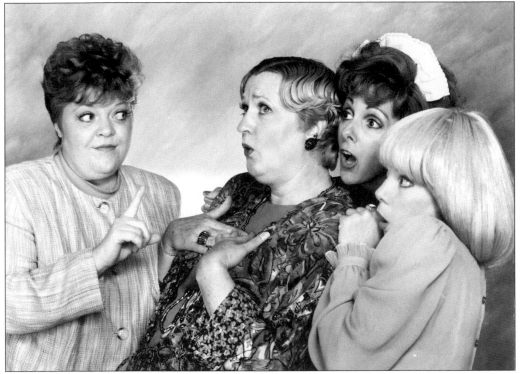

Dundalk's Community Theatre provides excellent live productions each year from the theatre at CCBC's Dundalk Campus. This scene, from the 1980–1981 season, featured, from left to right, Nancy Tarr Hart, Peggy Spillane-Moser, Nadine Haas-Wellington, and Marci Erin Daniels in *Something's Afoot*. (Courtesy Dundalk–Patapsco Neck Historical Society Museum.)

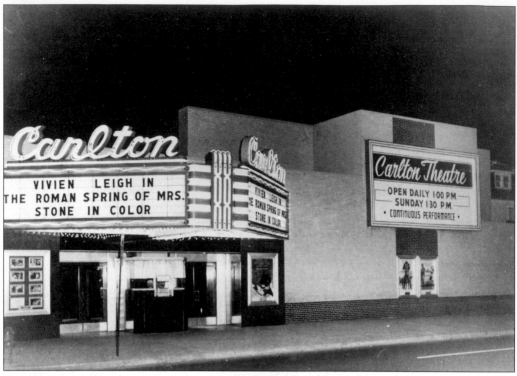

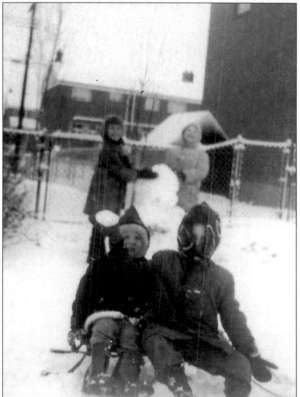

The Carlton, at 1201 Dundalk Avenue, entertained scores of patrons from 1949 to 1978. The author recalls waiting in lines that stretched around the corner and up Graceland Avenue to see a Disney film, double-feature horror flicks from Hammer Studios, or the latest Jerry Lewis comedy of the 1960s. Here's a bit of Carlton trivia; the first film ever shown, on February 22, 1949, was *Mexican Hayride* starring Abbott and Costello. (Courtesy Dundalk–Patapsco Neck Historical Society Museum.)

Of course, when all else fails, kids can still create their own fun as these Wareham Road boys and girls did on a winter day in the mid-1960s. The occasional big snowfall, while the bane of motorists, is always welcomed by youngsters. (Courtesy Marcee Zakwieia.)

Eight

MOMENTS TO REMEMBER

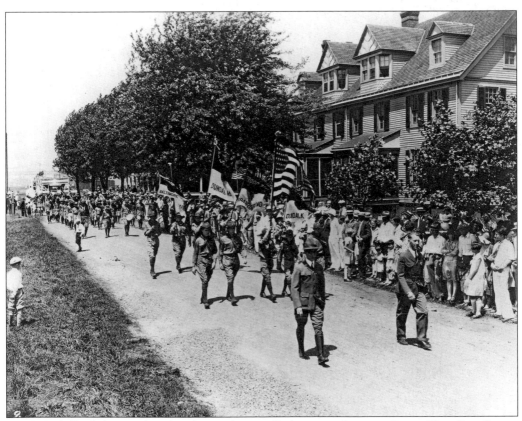

The Dundalk tradition of a July 4th parade actually began in Sparrows Point. Here Boy Scouts from Baltimore, Dundalk, and Sparrows Point march along B Street in the 1920s. (Courtesy Dundalk–Patapsco Neck Historical Society Museum.)

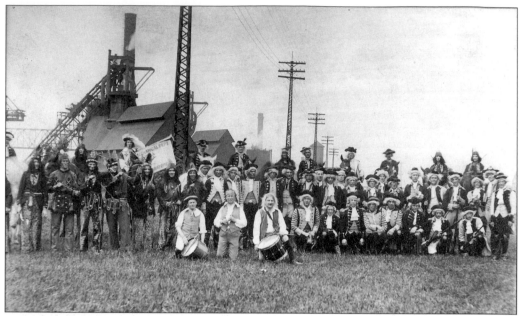

Bethlehem Steel Mechanical Department employees in costume as Native Americans and patriots, some on horseback, struck this pose in the early 1900s. (Courtesy Dundalk–Patapsco Neck Historical Society Museum.)

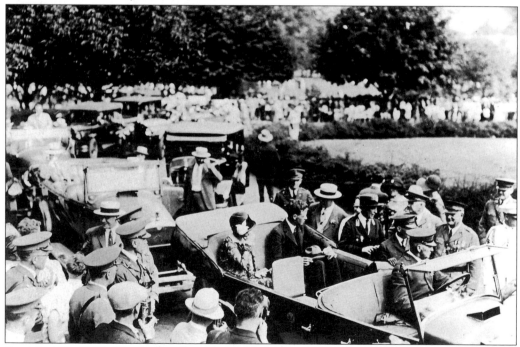

On May 21, 1927, Charles Lindberg landed his plane, *The Spirit of St. Louis*, in Paris after completing the first solo trans-Atlantic flight. Less than a month later, on June 18, 1927, he visited Logan Field and can be seen with Mrs. Lindberg in the first open car. Among the thousands waiting to greet him in Dundalk was Gen. Douglas MacArthur. (Courtesy Dundalk–Patapsco Neck Historical Society Museum.)

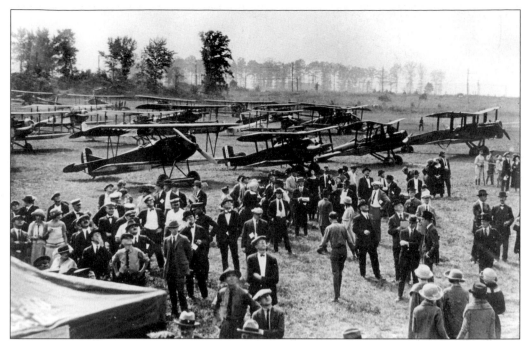

Air shows, like this one at Logan Field in the early 1930s, attracted lots of flyers and even more spectators. Visitors continue to flock to the site of Logan Field today, only now it's for the gastronomical delights that are Captain Harvey's steak subs. (Courtesy Dundalk–Patapsco Neck Historical Society Museum.)

The arrival to Dundalk of the first Pan Am Clipper seaplanes around 1937 was a big deal, attracting hundreds of spectators and the local media. Here standing before the WFBR radio mobile van were, from left to right, Gladys Marsheck, Virginia Echols, Louise Chell, and Antionette Chell. (Courtesy Dundalk–Patapsco Neck Historical Society Museum.)

Actor Tyrone Power and wife, Annabella, flew in to Logan Field in the late 1930s. (Courtesy Dundalk–Patapsco Neck Historical Society Museum.)

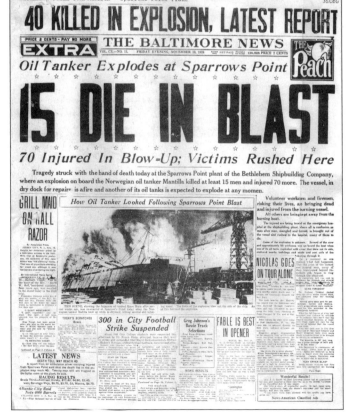

This headline from November 19, 1926, described the explosion of the Norwegian oil tanker *Mantilla*, which was at the Bethlehem Steel Shipyard dry dock for repairs. Forty men died in the blast. (Courtesy Dundalk–Patapsco Neck Historical Society Museum.)

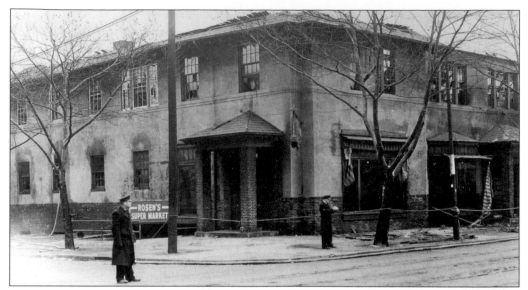

Caplan's Department Store at Eighth and D Streets in Sparrows Point was destroyed by fire on a winter day in 1945. Sparrows Point Police made sure the curious kept their distance. (Courtesy Dundalk–Patapsco Neck Historical Society Museum.)

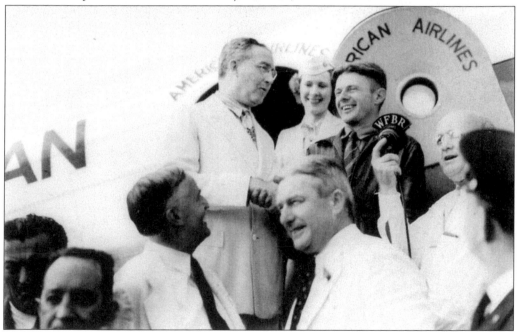

On July 17, 1938, aviator Douglas Corrigan took off from Brooklyn, New York, in a modified Curtiss Robin bound for California. Twenty-eight hours later, he landed in Dublin, Ireland, and became internationally famous as Douglas "Wrong-way" Corrigan. Truth be known, Corrigan had been trying to secure government permission to fly to Ireland for three years but had been constantly denied, so many believe the planned flight to California was all a ruse. Later that year, he came to Baltimore to visit relatives. Landing in Dundalk at Logan Field, he was mobbed by well-wishers, including aviation giant Glenn L. Martin, seen here shaking Corrigan's hand as he exited an American Airlines DC-3. (Courtesy Dundalk–Patapsco Neck Historical Society Museum.)

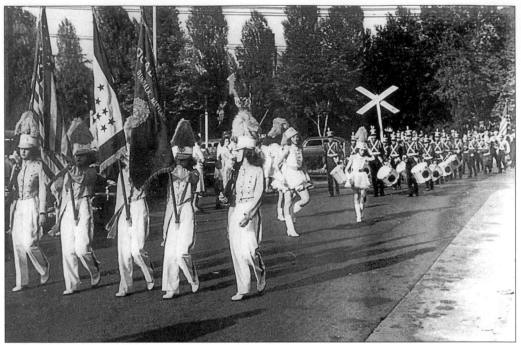

Photographs from Dundalk's July 4th parades could fill volumes by themselves. This one, from 1940, features American Legion Post No. 38. (Courtesy Virginia Gallick.)

Waiting for the 1955 parade (and looking none too pleased about it) were Kathy LaPaglia (left) and Monica Zakwieia. Dundalk families have a long-standing tradition of staking out their parade-watching spot the night before. (Courtesy Marcee Zakwieia.)

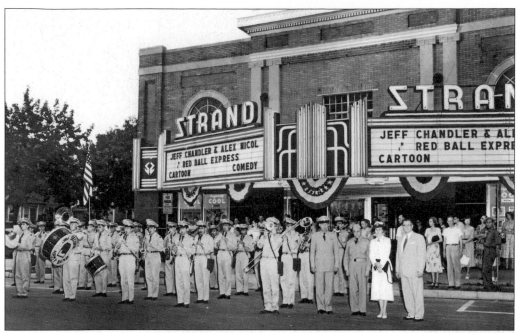

In 1952, the 2nd Army Band stopped to perform in front of the Strand Theatre. (Courtesy Baltimore County Public Library.)

In 1979, Mollie McShane Fenger, granddaughter of William McShane, who gave Dundalk its name in 1894, presented a McShane bell to the people of Dundalk. The bell is located in Heritage Park, at Dunmanway and Trading Place. (Courtesy Dundalk–Patapsco Neck Historical Society Museum.)

Anxiously awaiting his first parade, two-year-old Jason Helton gnaws on a miniature American flag near the Liberty Parkway reviewing stand in 1980. (Photograph by author.)

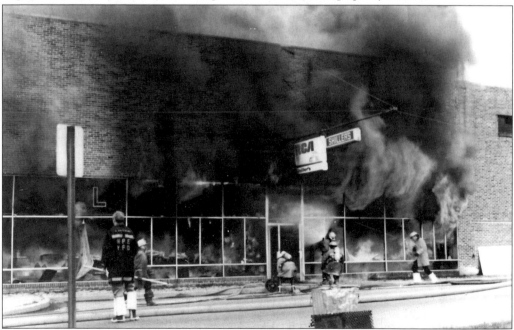

Not all of Dundalk's defining moments have been pleasant ones. On October 22, 1984, a five-alarm fire destroyed the Shiller's Furniture store on Holabird Avenue, taking the lives of Dundalk firefighters Walter Bawroski, James Kimbel, and Henry Rayner Jr. (Courtesy Dundalk–Patapsco Neck Historical Society Museum.)

In 1995, puppeteer and former Turner Station resident Kevin Clash returned to Dundalk and paid a special visit to the Dundalk–Patapsco Neck Historical Society Museum. With him on this trip was Elmo of the PBS children's television show *Sesame Street*. Clash got his start on the local kid's show *Caboose* with the late Stu Kerr. From there, he went to the long-running CBS series *Captain Kangaroo*, then on to *The Great Space Coaster*. Clash eventually attracted the attention of legendary Muppets creator Jim Henson. In addition to *Sesame Street* and other Henson productions, Clash has worked on the ABC series *Dinosaurs*, where he operated and voiced Baby Sinclair ("Not the mama!"). With Clash and Elmo are museum volunteers, from left to right, Bertha Hartlove, Lil Tirshman, Eleanor Lukawich, Barbara Meyers, and Gladys Echols. (Courtesy Dundalk–Patapsco Neck Historical Society Museum.)

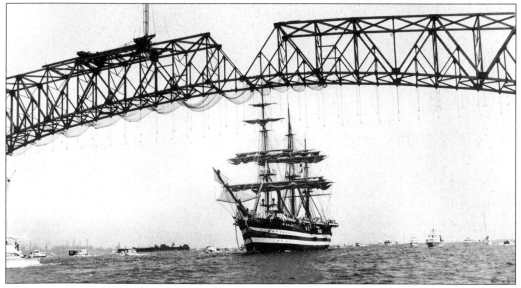

The most beautiful of the tall ships to visit Baltimore for the nation's 1976 bicentennial celebration was the *Amerigo Vespucci* of Italy. It is seen here off Dundalk, passing beneath the unfinished Francis Scott Key Bridge, escorted by dozens of local pleasure craft. (Courtesy Dundalk–Patapsco Neck Historical Society Museum.)

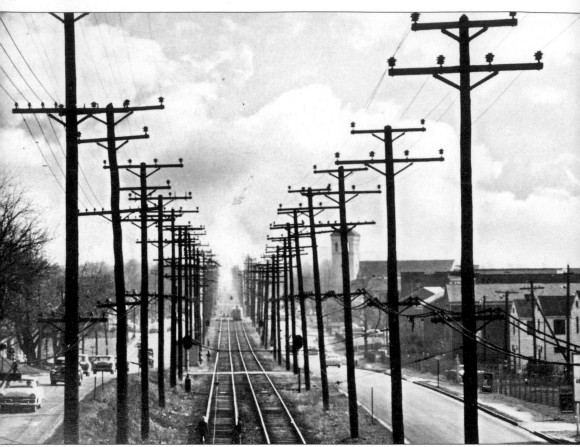

In this shot taken around 1957, both streetcars and automobiles can be seen moving along Dundalk Avenue. From the photographer's vantage point on the railroad overpass, the barracks of Fort Holabird are visible at the right, while the spire of St. Timothy's can be seen in the distance. (Courtesy Dundalk–Patapsco Neck Historical Society Museum.)